PRESTEL MUSEUM GU

D0836659

Städtische Galerie im Lenbachhaus Munich

Edited by
Helmut Friedel

Prestel
Munich · New York

© Prestel-Verlag,
Munich · New York · 1995

The manuscript is based on texts by
Barbara Eschenburg, Helmut Friedel,
Annegret Hoberg, Susanna Partsch,
and Ulrich Wilmes

Translated from the German by
Michael Robertson
Copyedited by Natalka Koch

Photos:
Städtische Galerie im Lenbachhaus
(Simone Gänsheimer, Ernst Jank,
Jörg Koopmann)
Pp. 10/11: Michael Wesely
Pp. 32, 35, 40, 41, 43: Gabriele
Münter and Johannes Eichner
Foundation

Front cover:
Franz Marc, *The Tiger*, 1912
Back cover:
Outside view of the Lenbachhaus,
1993. Städtische Galerie im Lenbach-
haus, Simone Gänsheimer.

© for illustrated works, when not held
by the following artists or their estates:
Rudolf Belling, Joseph Beuys, Christian
Boltanski, Heinrich Campendonk,
Lovis Corinth, Robert Delaunay, Dan
Flavin, Alexei von Jawlensky, Vassily
Kandinsky, Paul Klee, Gabriele Münter,
Blinky Palermo, Richard Riemer-
schmid, Richard Serra, Max Slevogt,
Lawrence Weiner, is with VG Bild-
Kunst, Bonn, 1995

Prestel-Verlag
Mandlstraße 26
80802 Munich
Telephone +49-89-38 17 09-0
Telefax +49-89-38 17 09-35

Design:
Konturwerk, Rainald Schwarz
Lithography: Krammer, Munich
Typeset in Sabon and Frutiger
Printing and binding: Passavia, Passau

Printed in Germany
ISBN 3-7913-1623-0

Städtische Galerie im Lenbachhaus
Luisenstrasse 33
80333 Munich
Telephone +49-89-23 33 20-00
Telefax +49-23 33 20-03/4

Opening hours:
Lenbachhaus
10 a.m.–6 p.m.
Kunstbau
(Königsplatz underground station)
10 a.m.–8 p.m.
daily except Mondays
Open on Easter Monday and
Whit Monday
Closed on Shrove Tuesday and 24 and
31 December

Library:
Specialist collection of modern and
contemporary art

Kubin Archive:
Documents and source materials on
Alfred Kubin, particularly his corres-
pondence with numerous artists

Graphische Sammlung:
Collection of graphic works by nine-
teenth-century Munich artists and by
"Blue Rider" artists

Café:
Barbara Holzherr and Christoph
Jünger, telephone 0 89-5 23 72 14

Museum shop:
Gabriele Röhl, telephone 0 89-52 58 79

Die Deutsche Bibliothek – CIP-Ein-
heitsaufnahme

Städtische Galerie im Lenbachhaus
Munich / ed. by Helmut Friedel. [Based
on texts by Barbara Eschenburg …
Transl. from the German by Michael
Robertson]. – München ; New York :
Prestel, 1995
 (Prestel museum guides)
 Dt. Ausg, u.d.T.: Städtische Galerie im
 Lenbachhaus München. –
 Nebent.: Lenbachhaus Munich
 ISBN 3-7913-1623-0
NE: Friedel, Helmut [Hrsg.]; Eschenburg,
 Barbara; Lenbachhaus Munich

Contents

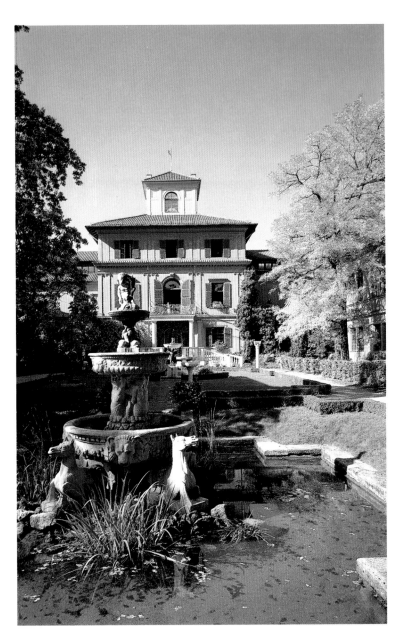

The international reputation of the Lenbachhaus, the villa that was formerly the residence of the 'prince of painters' Franz von Lenbach, is based on its unique collection of works by the 'Blue Rider' (*Blauer Reiter*) group. In addition, however, the Städtische Galerie im Lenbachhaus also offers insights into nineteenth-century Munich painting. Largely due to its consistent policy of holding special exhibitions of contemporary art, the gallery has also made substantial purchases of works by significant representatives of more recent art during the last twenty years.

The History of the Building

After years in which he was constantly moving house and travelling, Franz von Lenbach (1836–1904) decided, at the peak of his career, to settle in Munich—which at that time was the most important centre for the fine arts in Germany. The choice of a site for his new residence was highly significant in relation to what Lenbach intended for it. In the immediate vicinity of the Classicist buildings on the Königsplatz, built by the Bavarian King Ludwig I, and opposite the Propylaeum—on a site that was thus outside of the then city boundaries—he found an opportunity to make his villa a focus of artistic society. And it is not only Lenbach's affinity with the royal patron of the arts—whose immense achievements began to be recognized and appreciated belatedly towards the end of the nineteenth century—that the villa's site expresses, but also his close relationship to the art of the Old Masters, as collected in the nearby Pinakothek galleries, as well as the classical sources collected in the Glyptothek. Lenbach hoped to revive the image of the 'prince of painters', in imitation of Titian and Rubens, whom he prized highly and had intensively studied and copied—so much so that he claimed to be able to imitate their palettes from memory. It had become a matter of prestige for important society personalities during Germany's period of rapid industrial expansion, the so-called *Gründerzeit*, to have their portraits painted by Lenbach—so that the outward conditions were secure for the ambitious undertaking of planning an artist's residence that was to be simultaneously a home, a studio, and a museum. In building his villa, Lenbach was making a claim to social recognition in the same way that Defregger, Stuck, Kaulbach, and others were doing. 'I intend to build a palace that will overshadow everything that has gone before,' Lenbach wrote to a correspondent in 1855. 'The powerful centres of great European art will be given a link to the present day in it.'

In its architecture, the Lenbachhaus imitates the form of the Tuscan villa. The decision in favour of a freestanding building on an Italian model was influenced by the extensive periods Lenbach had spent in Rome and Tuscany. He won over the famous Munich architect Gabriel von Seidl (1848–1913) to realize his plans, and the artist's villa was completed within only a few years (1887–91) through the two men's collaboration.

The Lenbach villa consisted of a central domestic unit and a studio building on the south side, towards Brienner Strasse, with gardens subdivided by fountains. Following various architectural models, and with the aid of decorative pieces (mostly imitated from classical models), a location was thus created that was capable of providing a background for the prestigious social functions that were expected during the *Gründerzeit*. The artists' parties, to which Lenbach himself enthusiastically contributed, typified the façade-like, and even mask-like, attitudes of the time. The overall conception of his villa, with a flight of steps, pillars, loggias, swinging arch forms, terracotta vessels, stucco bas-reliefs, etc., is based on a painterly vision. The building's attention to the exterior seems to be more significant than any overall architectural and spatial consistency. The interior, too, of which only some rooms on the piano nobile of the domestic building and the entrance hall remained

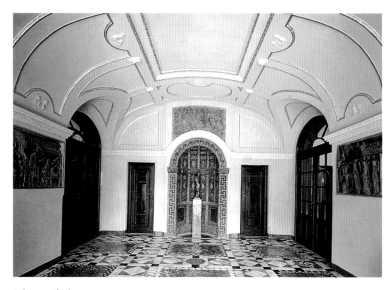

The vestibule

after bombing during the war, is dominated by an almost façade-like architectural effect. The rich original decoration, using a wide variety of decorative elements, included priceless classical sculptures, medieval paintings, rare tapestries and Gobelins, as well as copies of classical reliefs when original pieces could not be found. The extravagance of the decoration throughout the interior produced a pompous, but also a dull, note. All this splendour was the materialization of everything that in Lenbach's time was thought appropriate to the residence of a 'prince of painters'. It was an appropriate prestige location for the most distinguished guests; during his visit in 1892, Bismarck received the ovations of the Munich crowd from the villa's balcony.

The studio and domestic building were connected when extensions were carried out around 1900, without altering the character of the ensemble as a whole.

Franz von Lenbach died in 1904. Lolo von Lenbach, his widow, decided in 1924 to sell the estate to the city of Munich, and when negotiations were completed, she also donated to the city a large number of artworks from Lenbach's collection, belonging to the inventory of the painter's residence. A substantial portion of the artist's paintings were also transferred to the city's collections. It then became possible to realize the long-cherished dream of establishing a City Art Gallery. Only a year after the purchase of Lenbach's villa had been completed, the city provided funds for the acquisition of artworks, funds that were doubled in each of the succeeding years. Within quite a short space of time, therefore, it was possible to significantly increase—both in qualitative and quantitative terms—the stock of artworks held by various local government institutions. A new wing opposite the studio, designed by Hans Grässel (1860–1939) in a noble, reserved formal language, extended the artist's villa harmoniously into a three-winged building. In 1929, the Lenbachhaus, which now combined the Städtische Galerie

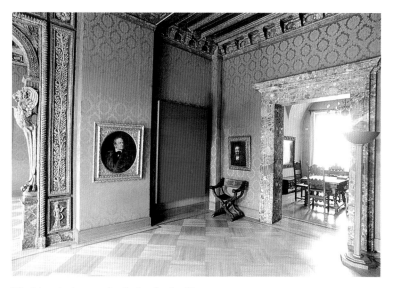

The historical rooms in the Lenbach villa

(City Gallery) and the Lenbach gallery under one roof, was opened to the public for the first time.

After severe damage during the war, with substantial sections of the building being destroyed in 1944–45, a few thoroughly renovated rooms on the first floor of the central building can only give a distant impression today of the original magnificence of Lenbach's decorative art. As early as 1947, after speedy rebuilding work, the first postwar exhibitions were shown in the north wing. In 1952, the interior of the studio building was renovated, and the restoration of the top-lit halls on the northwest side followed.

Despite restricted resources, the collection continued to be extended during the post-war years, particularly with works by contemporary artists.

With a magnificent donation from Gabriele Münter, on the occasion of her eightieth birthday on 19 February 1957, the Städtische Galerie then at a single stroke came into possession of an outstanding collection that turned the Lenbachhaus overnight into a museum of world significance. The museum acquired over 90 oil paintings, more than 330 watercolours and drawings, as well as sketchbooks, verre églomisé pictures, and almost all the prints produced by her longtime companion, Vassily Kandinsky, together with 25 paintings, numerous drawings and prints by Münter herself, as well as many works by their other artist friends in the Blue Rider circle, such as Jawlensky, Marc, Macke, and Werefkin. In addition to this, in the Bernhard Koehler Foundation presented the museum with a number of central works by Macke, Marc, Jawlensky, and Niestlé in 1965, from the estate of the Berlin manufacturer Bernhard Koehler—Elisabeth Macke's uncle and the great patron of the Blue Rider group. The collection was rounded off by the Gabriele Münter and Johannes Eichner Foundation, which came into being the following year, adding works by Baum, Bekhteyev, Bossi,

Ulrich Horndash, ceiling fresco above the stairwell, 1992

Werefkin, Delaunay, Jawlensky, Klee, Macke, Marc, and others. Over the years, it was also possible to add important works by Klee, thanks to purchasing funds provided by the city and by the Gabriele Münter and Johannes Eichner Foundation, as well as significant pieces by the major representatives of the Blue Rider.

Supplementing the significant archival material held by the Gabriele Münter and Johannes Eichner Foundation, the Kubin Archive of the Hamburg collector Dr. Kurt Otte was purchased in 1971. As well as numerous works by Alfred Kubin, the archive contains extensive correspondence with the avant-garde artists of the period.

With the purchase of its significant collection of works by the Blue Rider group of artists, none of whom had been represented in it up to that time, the museum underwent a complete reorientation. The collection not only documents Munich's contribution to classical modernist art in the decade preceding the First World War, it also brought the museum international renown. An extension built in 1969–72 provided the space and facilities required for adequate presentation of these extensive holdings.

Since the redesigning of the Blue Rider exhibition halls, which were reopened in 1992, the Blue Rider paintings now hang on walls, some of which are in bright primary colours, while others are painted in quiet, halting tones intended to emphasize the sensory effect of the colour aesthetics and special presence of the paintings.

These modernist works are today a focus of interest for an international audience, which would be loath to do without the charm of Lenbach's artist villa. Franz von Lenbach, who viewed the beginnings of the new art in Munich with severe reservations, is virtually a paradigm for everything the Blue Rider artists were trying to free themselves from.

Lawrence Weiner, Rock Hump, *1994*

Since the 1970s, the museum has been presenting in its exhibitions the essential trends and artists on the contemporary international art scene, and it has begun to collect contemporary art as well. Lawrence Weiner's *Rock Hump* of 1994, Maurizio Nannucci's neon work of 1991, *You Can Imagine the Opposite*, on the façade, and the ceiling fresco created in 1992 by Ulrich Horndash in the staircase of the Lenbach villa, witness to the most recent period.

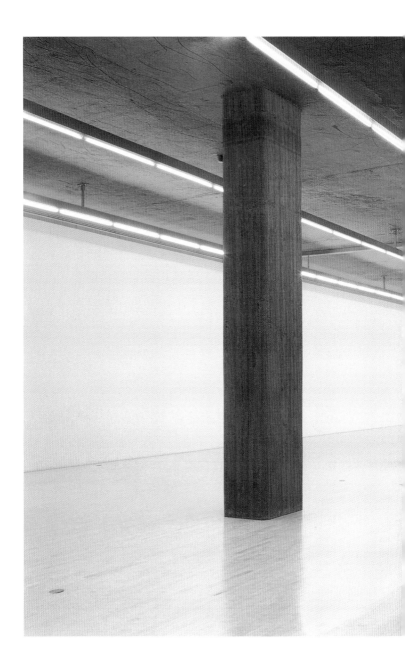

The completion of the Kunstbau (Art Building) immediately adjacent to the villa, to serve as the new exhibition hall for the Städtische Galerie im Lenbachhaus, has made it possible to mount visiting exhibitions on an entirely new scale. The increased space available has also made it possible to present contemporary art in the Lenbachhaus itself in a more prestigious and spacious way.

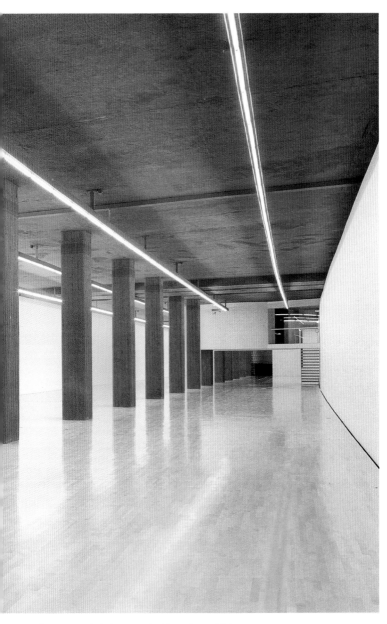

Dan Flavin, Untitled, for Ksenia, *Kunstbau 1994*

The Kunstbau is situated in an originally unused empty hall that had been constructed for technical reasons above the underground station at Königsplatz. The hall, slightly curved, 120 m long and some 16 m wide, is divided into two passages by the 18 concrete pillars running down its length. The architect, Uwe Kiessler, developed a design that was as simple as it was convincing. The large space remained almost

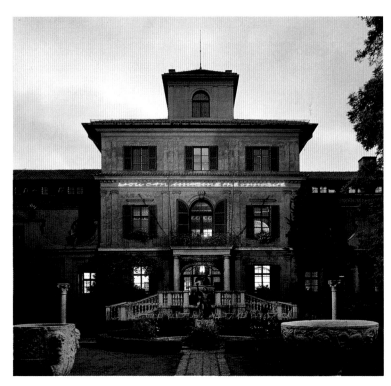

The façade of the Lenbachhaus, with Maurizio Nannucci's You Can Imagine the Opposite, *1991*

unchanged; the ventilation equipment was concealed behind white wall panelling, and the floor was given a wooden surface. A flexible track system on the ceiling, which was left in plain concrete, allows widely varying lighting arrangements to be made for each exhibition. At the back, there is an auditorium for film and video presentations.

Nineteenth-Century Munich Painting

The first half of the nineteenth century—the period between the 1789 French Revolution and the 1848 revolution in Germany—was marked by the struggles for the founding of a German state, against which stood the nation's historical division into numerous ministates and territories. Bavaria was one of the states that had gained in power and geographical extent during Napoleon's reorganization of Europe.

Under the first Bavarian king, Max I Joseph, the Academy of Fine Arts was founded in 1808 to train artists capable of carrying out public art commissions. One of the first *Kunstvereine* (Art Societies) in Germany was founded in Munich in 1823, at the instigation of Domenico Quaglio, Joseph Stieler, Peter Hess, and Friedrich Gärtner, giving fresh momentum to the bourgeois painting that had already been encouraged by the Elector Karl Theodor.

However, the most decisive figure in the artistic events of the first half of the century was King Ludwig I, who had been passionately interested in art even while he was still crown prince.

The painting of the time—in a period that ended with Ludwig I's abdication in 1848—was initially marked by efforts to establish a style of German national art distinct from the French-oriented art of the eighteenth century. The contrast between the idealistic painting that was favoured at court, above all under Ludwig I, and an incipient movement toward bourgeois naturalism, centred on the *Kunstverein*, became characteristic of the Munich art scene. As director of the academy, Peter Cornelius represented the idealistic historical painting that was particularly encouraged by Ludwig I, while the *Kunstverein* developed to become a forum for still life and genre painting, as well as landscape painting. Landscape painting grew to become the favourite genre for

View of Room 12

bourgeois art tastes, and with Carl Rottmann ultimately also became the object of public commissions. Important in the choice of subject matter for historical, genre, and landscape painting was the establishment of Otto I, Ludwig's son, on the throne of Greece.

With the opening of borders within Germany from 1830 onward, and particularly after 1848, making it easier to travel abroad as well, German painting began to emerge from its provincial isolation around the middle of the century. The metropolis of Paris once again became a magnet for artists, as it had been around 1800, and London, where the first World Exhibition was held in 1851, was also an attraction. Munich painting caught up with international developments particularly in the field of 'intimate landscape painting'. Decisive influences came from the French school of Barbizon, from the Dutch and Belgians, and from John Constable in England, who was the supreme master of the incipient painterly realism. The extent to which contemporaries were aware of international connections can be seen from the fact that Eduard Schleich the Elder, one of the initiators of 'intimate landscape' in Munich, was nominated to organize the First International Art Exhibition held at the Glaspalast (Crystal Palace) in Munich in 1869.

The reign of Prince Regent Luitpold (1886–1912) covers the epoch from what is now termed the *Gründerzeit*, to Art Nouveau (*Jugendstil*), i.e. the period from the founding of the German Empire in 1870–71 up to the First World War. Since the building of the Glaspalast to serve as an opulent exhibition building in 1854, Munich had increasingly attracted artists not only from Bavaria, but also from northern Germany, since there was an excellent art market in the city and the professors at the academy were renowned. At the exhibition in the Glaspalast in 1869, indigenous German art was officially set up for comparison with foreign art. Shortly afterwards, the first critical attacks began on the exhibition policies at the Glaspalast, which was dominated by the guild of artists under its chairman, Franz von Lenbach.

In 1892, the first German Secession was founded in Munich; its exhibitions were initially held on its own premises, although they were later admitted to the Glaspalast again. A wide variety of trends coexisted alongside one another in the Secession, which saw itself basically as being an association serving merely to lobby for a single common purpose. Franz von Stuck was a member, as well as figures such as Slevogt and Corinth. Munich was one of the most important centres for Art Nouveau in Germany. The German term for it, *Jugendstil*, was taken from the title of the journal *Jugend*, 'Youth', founded in 1896, the publication that ensured the style its widespread impact in Germany. Art Nouveau aimed to apply design concepts to the whole of life, from fashion to architecture and interior decoration, right down to painting, graphic art, and book design. The aesthetic movement opposing the eclecticism of the historicist approach was accompanied by a simultaneous movement towards a reformed lifestyle, aiming for a healthier life.

Right: Connecting rooms with works by nineteenth-century Munich painters. In the foreground is the bust of Goethe by Christian Daniel Rauch

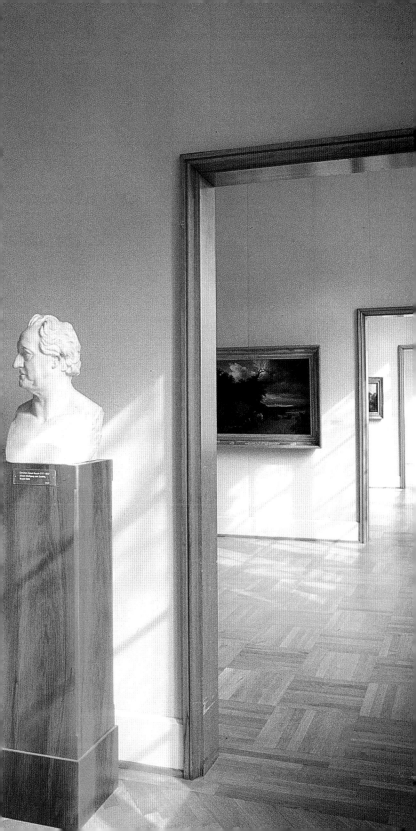

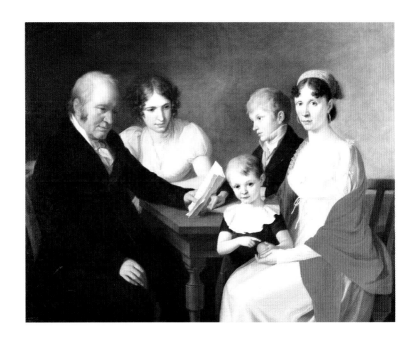

Joseph Hauber (1766–1834)
Scheichenpflueg Family, 1811
Oil on canvas, 124 x 156.5 cm
Although he also produced religious, mythological, and allegorical pictures, the Munich Academy professor and historicist painter Joseph Hauber's principal concern was with portrait painting. In this group portrait, the merchant Scheichenpflueg's family has gathered around him as he reads to

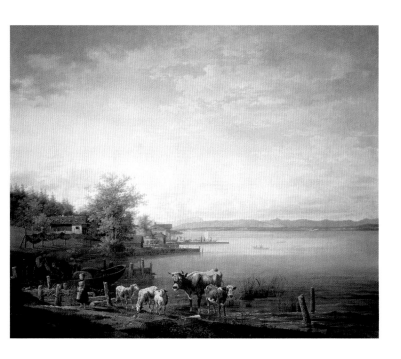

them from a letter. The family is presented both as a social institution and as a civic community based on emotional relationships.

Johann Georg von Dillis
(1759–1841)
In the Hirschgarten, near Munich, ca. 1830
Oil on paper, 23.5 x 30.6 cm
Dillis, who was Ludwig I's Gallery Director and artistic agent, was an influential and extremely busy figure, who nevertheless managed to use every free moment he had for drawing. The oil studies and watercolours by this representative of the first generation of landscape painters in the nineteenth century are unique, not only in Munich painting, but in German painting in general. The open-air studies he produced as early as the close of the eighteenth century anticipated developments that only emerged in German art much later, in the late 1820s.

Max Joseph Wagenbauer
(1775–1829)
Landscape at Lake Starnberg, 1813
Oil on canvas, 134 x 164 cm
Along with Johann Jakob Dorner the Younger and Simon Warnberger, Wagenbauer is one of the principal representatives of early naturalistic landscape painting, which was particularly encouraged by the Elector Karl Theodor and by Max I Joseph. The *Landscape at Lake Starnberg* was produced in connection with a commission by Max I Joseph for designs for landscape tapestries illustrating the Bavarian lakes, to decorate the Badenburg in the park of the largely Baroque palace of Nymphenburg. Typical features of Munich landscape painting are Biedermeier genre scenes, which are here pushed down to the lower edge of the picture. The depiction of the immediate homeland expresses a turning away from idealism towards national awareness.

Wilhelm von Kobell (1766–1853)
After the Hunt at Lake Constance, 1833
Oil on wood, 42 x 55.5 cm
Together with his father Ferdinand, Wilhelm von Kobell was one of the artists whom the Elector Karl Theodor brought to Munich from Mannheim. At the beginning of the nineteenth century, he developed his own style based on seventeenth-century Dutch painting. Spatial clarity, infinite breadth in the landscape, and colourful realistic detail in genre-like foreground scenes, are the marks of his idealizing depictions of a serene rural life, portrayed as the form of free existence best suited to human nature.

Carl Rottmann (1797–1850)
Cloud Study near Murnau, ca. 1843
Oil on paper over canvas, 30 x 61.5 cm
Alongside naturalistic landscape painting, encouragement from Ludwig I led to the development of an independent, heroic, or historicizing form of landscape painting as well. Carl Rottmann, who came to Munich from Heidelberg to study in 1821, was the founder of this tendency. His specific contribution to heroic landscape painting consisted of combining both aspects of landscape painting that he had encountered in Italy: the technique of realistic, spontaneous oil sketching from nature—of which his *Cloud Study* is an example—and the composition of classical landscapes, i.e. depicting an ideal world, the remnants of which were thought to be embodied in Italy, or later in Greece.

Heinrich Bürkel (1802–1869)
Driving the Cattle to the Alpine Pasture on the Benedikten-wand, 1836
Oil on canvas, 64 x 85 cm
The second generation of Munich artists, who had been stimulated by the arrival of painters from the North during the 1830s, fused the clarity and colourfulness of early Munich landscape painting with a new interest in specific phenomena in the sky and in geological formations, developing a new type of painterly realism. Among them, Heinrich Bürkel was the master of genre landscape. *Driving the Cattle to the Alpine Pasture* is an impressive example of his transfigurative depiction of peasant life.

Ernst Kaiser (1803–1865)
View of Munich from Oberföhring, ca. 1839
Oil on canvas, 87 x 119 cm
Kaiser, who shared a studio with Heinrich Bürkel, succeeds in his *View of Munich from Oberföhring* in connecting very precise studies of the microcosm of areas of lawn and the edges of slopes with a landscape of panoramic breadth, marked by the excessive clarity of contours seen when the *Föhn* wind is blowing from the Alps.

Carl Spitzweg (1808–1885)
Companions from Youth,
ca. 1855
Oil on canvas, 30 x 42.5 cm
Spitzweg, a pharmacist, was an amateur painter. Like his friend Eduard Schleich, he was one of the Munich artists who travelled to Paris, London, and Antwerp as early as 1851 to get to know the current trends in international painting. In his painting *Companions from Youth*, the typification of the two principal figures is as original as the choice of the spatial detail in which the two dissimilar friends—the one who has remained at home and the one who has travelled widely—encounter one another, as if on stage. Spitzweg succeeded here, as in some of his other pictures, in achieving a form of personal characterization that is typical above all of English and French caricature. The human race seems to have been distorted into a grotesque and peculiar species.

Wilhelm Leibl (1844–1900)
Veterinarian Reindl in the Arbour, ca. 1890
Oil on wood, 26 x 19.5 cm
The 'purely painterly' was the central interest in the painting of Leibl and his circle, which included Wilhelm Trübner, Carl Schuch, and Johann Sperl, among others. With no ambitions for academic office or social position, they withdrew to the country and attempted—in close collaboration, mainly during the 1870s and 1880s—to achieve 'honesty' in painting. In contrast to the historical style of the *Gründerzeit*, Leibl's *alla prima* pictures, produced using a single layer of paint, were restricted to motifs such as still lifes, landscapes, or portraits.

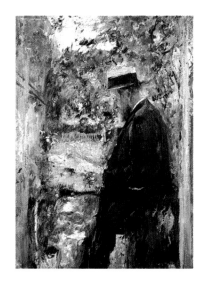

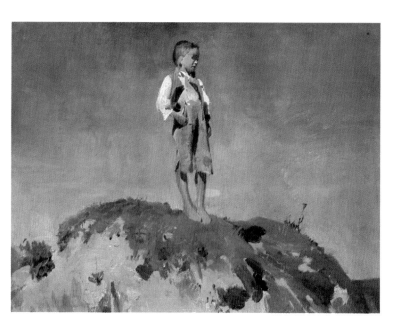

Franz von Lenbach (1836–1904)
Shepherd Boy on a Grassy Knoll, ca. 1857
Oil on board, 35.5 x 48 cm
Franz von Lenbach's artistic career began in 1857 with his admission to the famous school of Karl von Piloty, who enabled him to travel to Italy for the first time in 1858. He made an intensive study of the effects of light while he was in Italy, producing a number of sketches on which he later based his paintings. The shepherd boy is a recurrent motif found frequently in the early work of this significant representative of Munich realism. The pictorial idea, executed in a series of variations, heralds the famous painting entitled *Shepherd Boy* that now hangs in the Schack Gallery, Munich.

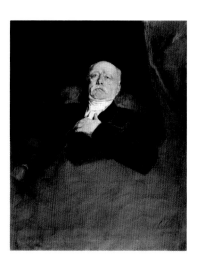

Franz von Lenbach (1836–1904)
Otto, Prince Bismarck, 1895
Oil on canvas, 130 x 103.5 cm
The first commission for a portrait of Bismarck in 1879 represented Lenbach's breakthrough as a portrait painter. The German Chancellor was from now on to be the painter's favourite model. This late portrait shows the eighty-year-old Bismarck, leaning back with a broad, heavy figure, in an armchair. While his clothing and the background are at best sketchily depicted, the entire focus —characteristically for Lenbach's portrait style—is on the head. Lenbach

used a photograph as his source— a technique seen in many of his portraits.

Franz von Lenbach (1836–1904)
Franz von Lenbach with his Wife and Daughters, 1903
Oil on cardboard, 96.5 x 122 cm
This family portrait was also based on a photograph of the group of figures. The painting was probably intended by the artist as a kind of bequest, as he was already seriously ill. It shows Lenbach with his daughter from his first marriage, Marion (custody for her was awarded to the father after his divorce), together with his second wife, Lolo, and their daughter Gabriele. The outlines of the figures were transferred to the art board using a tracing process. The artist's right hand is holding the camera's shutter release, and the heads are placed close together to ensure that they all fit inside the shot. The picture's vanishing point has obviously been shifted outwards to the point of focus of the camera lens. The ordering concept of the vanishing point, providing the image with fictive depth, a concept that had been fundamental in European painting since Giotto, seems here to have been overturned, externalized, and thus cancelled. The modernity of this approach can be seen when it is compared with the radical framework of Pop Art.

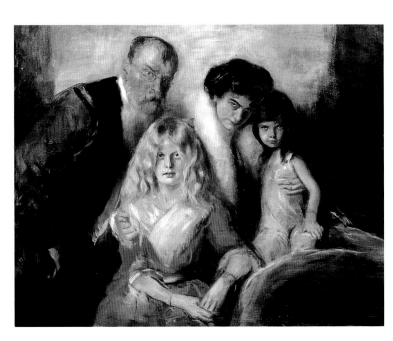

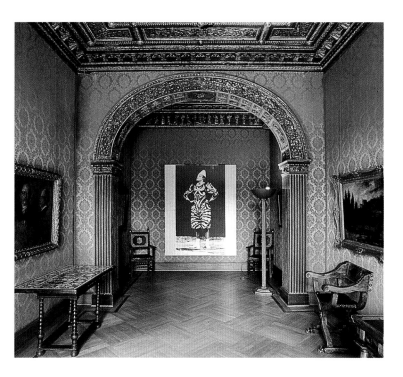

The historical Lenbach rooms, with works by Gerhard Merz

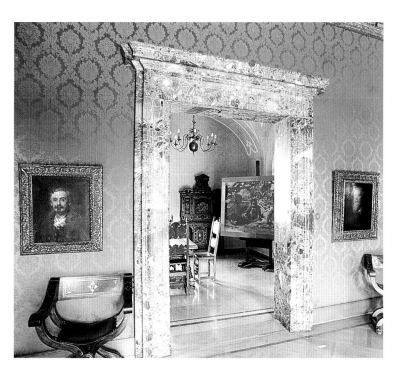

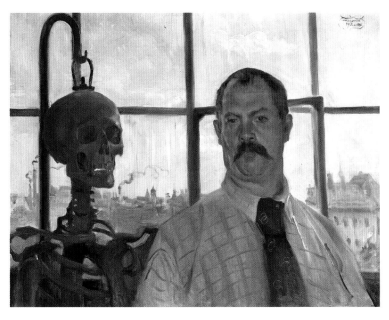

Lovis Corinth (1858–1925)
Self-Portrait with Skeleton, 1896
Oil on canvas, 68 x 88 cm

Corinth was a student of Franz von Defregger and Ludwig Löfftz at the academy in Munich. In 1892, he was one of the founding members of the Munich Secession. He is one of the most versatile and lively German painters of the turn of the century. The *Self-Portrait with Skeleton* is a variation on an old theme—artist and death—a subject which is reinterpreted here both naturalistically and at the same time ironically. The skeleton, indicating death, hanging from the hook, is only an anatomical model without any vitality or dynamism. Contrasting with it, the artist's arching chest shows his abundant energy. Corinth often produced self-portraits on his birthdays—which is the reason for the emphasis here on his age being 38, which is noted in the painting. The view from his studio in Giselastrasse opens onto the rooftops of Schwabing. Constructed out of pure colour tones without any darker areas, much of the picture, and especially the background, is painted using the Impressionist technique.

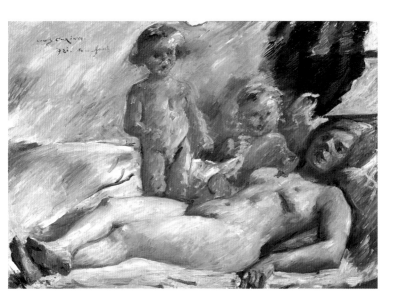

Lovis Corinth (1858–1925)
Nude with Putti, 1921
Oil on canvas, 140 x 200 cm
Among the works Corinth produced at the Walchensee during his last years is the great painting *Nude with Putti*. The energetic, broad brush stroke here is characteristic of his late style. Corinth processes the canvas as if he was using a chisel to achieve parallel hatching. The artist is overcoming a handicap resulting from a heart attack by using a new, strong form of expression. Once again, he takes up a mythological subject here, but all that remains of its literary content—Venus and Amor—is a description of the general situation: woman and children.

Max Slevogt (1868–1932)
Danaë, 1895
Oil on canvas, 92.5 x 81.5 cm
In addition to Corinth and Max Liebermann, Slevogt was one of the most significant German Impressionists. His *Danaë* was removed from the Secessionist ex-

hibition of 1899 before it opened, for fear of public scandal due its crude realism. The painting shows one of the many amorous adventures of the father of the Greek gods, Zeus. Danaë, imprisoned in a tower by her father, is approached by Zeus in the form of a shower of gold—an ancient subject that Slevogt intepreted as a depiction of procuration, turning the shower of gold into a gift of money. The profane treatment of a mythological subject must also been seemed potentially scandalous.

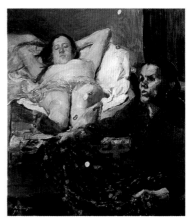

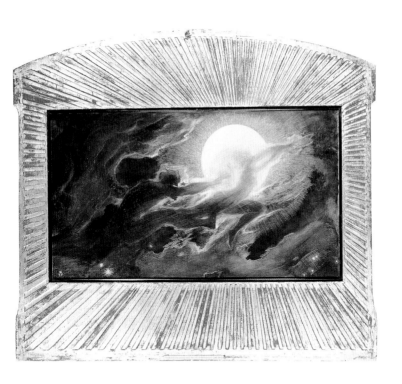

Richard Riemerschmid
(1868–1957)
Cloud Ghosts I, 1897
Wax crayon on cardboard,
63 x 87 cm (with frame)
Richard Riemerschmid, an architect and craft artist, was one of the outstanding protagonists of the Art Nouveau movement in Munich. In 1897, he was one of the founders of the *Vereinigte Werkstätten für Kunst im Handwerk* (United Arts and Crafts Workshops) in Munich. The Lenbachhaus owns several pieces of furniture from his home in Pasing. In his early period, shortly after 1900, and again after the 1940s, he was also active as a painter. The painting *Cloud Ghosts I*, in the original frame designed by the artist himself and serving as an extension of the image, enigmatically suggests an obsessive relation to sexuality, which was then a widespread subject in art. The coupling of a satyr and a nymph is depicted in a form as evanescent and capricious as the passing clouds on a moonlit night. Rodin entitled a small bronze sculpture with a similar motif *Fugit Amor*, and the work may have served as a model for Riemerschmid.

Left: view from Room 18, with works by Art Nouveau artists in Munich, through Room 17 to the portrait of Carl Strathmann by Lovis Corinth in Room 16

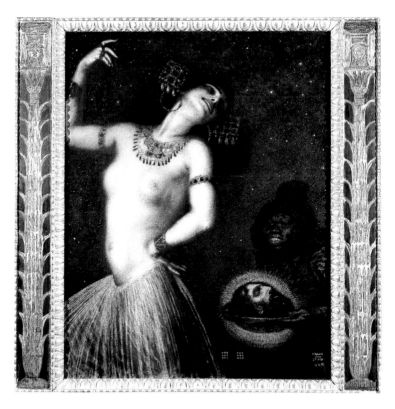

Franz von Stuck (1863–1928)
Salome, 1906
Oil on canvas, 121 x 123 cm
(with frame)
The best-known representative of the Munich-based Art Nouveau movement is Franz von Stuck, who, like Lenbach, rose from comparative poverty to become a 'prince of artists', and between 1897 and 1913 designed and built an even more opulent villa than Lenbach's on the opposite bank of the river Isar. Like Riemerschmid, Stuck was not only active as a painter, but also as a sculptor, architect, and interior decorator. The painting of *Salome*, the daughter of Herodias and the stepdaughter of Herod, who according to the New Testament demanded the head of the imprisoned John the Baptist as a reward for the dance requested of her by her stepfather, is known to have been inspired by a dance interpretation of Oscar Wilde's play *Salome* that was first performed in Munich in 1904. It was a period in which an expressive dance movement was developing, a very subjectively oriented style that was often performed in what for the time was shockingly scanty dress. Stuck was Vassily Kandinsky's teacher at the Munich academy.

Right: Munich Art Nouveau paintings, sculpture, and furniture in Room 18

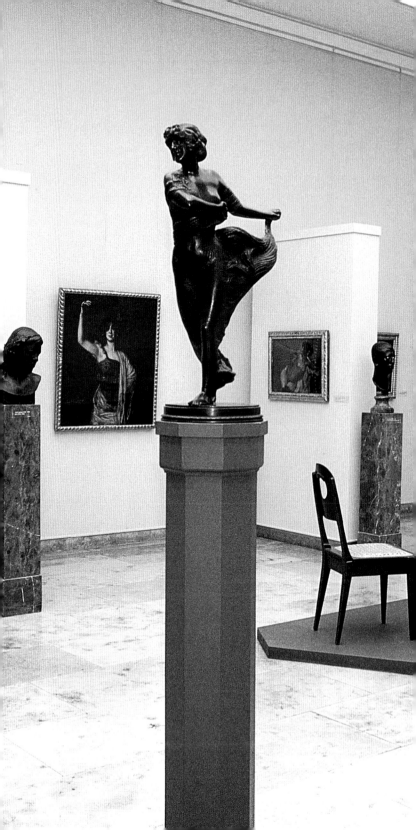

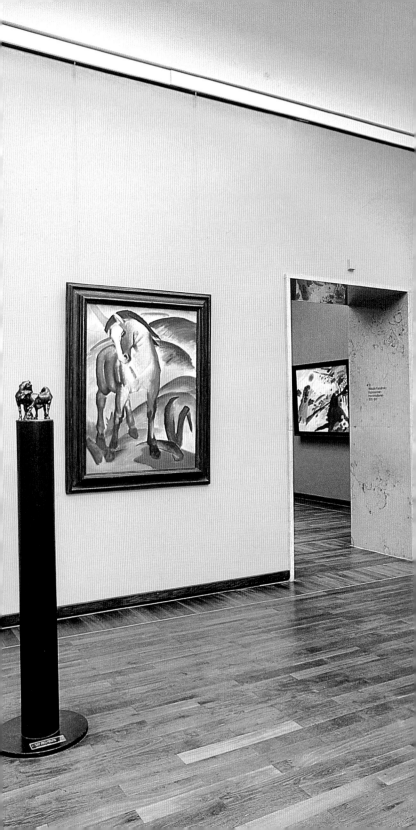

The Blue Rider

The *Blauer Reiter* (Blue Rider) movement started with a scandal, as has usually been the case in the history of modern art. The rejection of Kandinsky's great painting *Composition V* by the exhibition jury for the 'Neue Künstlervereinigung München' caused a sensation. Vassily Kandinsky, Franz Marc, Gabriele Münter, and Alfred Kubin resigned from the 'Neue Künstlervereinigung München', and organized their own exhibition, which went down in history under the title 'First Exhibition by the Editorial Board of *Der Blaue Reiter*'. The exhibition, which took place from 18 December 1911 to 1 January 1912 in the halls of the Galerie Thannhauser, became a demonstration that had epoch-making significance, and was certainly the most important artistic event that has taken place this century in Munich.

During the previous summer, Kandinsky and Marc had already planned an art almanac, which they later entitled *Der Blaue Reiter*. The text, the most important one relating to modern art in all the German-speaking countries, was entirely the work of Kandinsky and Marc in terms of its editorial and conceptual content.

Like many other Russian artists, Vassily Kandinsky came to Munich because, with its rather village-like character, it was an attractive alternative to the anonymity of the big city in Berlin and Paris. In addition to a whole variety of stimuli that Munich was capable of providing, its primary attraction was the thorough artistic training that it offered.

Kandinsky had abandoned his academic career in law in Moscow in favour of art, and he moved to Munich in 1896. There he met Alexei Jawlensky and Marianne von Werefkin, who unlike him had already completed their art studies in St. Petersburg. Like Jawlensky, Kandinsky took private art lessons from the Slovenian Anton Azbè (1859–1905), and around 1900 he studied for a year at the Academy under Franz von Stuck.

Together with other progressive personalities on the Munich art scene of the time, Kandinsky founded a private art school, the 'Phalanx', in 1901; in the years that followed, the school also organized important exhibitions. It was through the Phalanx that artists such as Claude Monet, Alfred Kubin, and the French neo-Impressionists were introduced to the Munich public.

In 1902, Gabriele Münter entered Kandinsky's Phalanx class as a student. At that time, women were not yet allowed to attend the Munich Academy of Art, and they therefore had to look for artistic training opportunities at private schools. During frequent bicycle trips in the country when the painting class was staying in Kochel in the summer of 1902, Kandinsky and Münter became personally close.

From the spring of 1904, the couple travelled widely, including trips to Holland and Tunis. They briefly stayed in Innsbruck, Starnberg, and Dresden; at the beginning of 1906, they lived for several months in Rapallo, then for a year in Sèvres, near Paris, and in 1907–8 in Berlin. They finally returned to Munich in June 1908. Kandinsky moved into a

Left: view from Room 21, with paintings and sculptures by Franz Marc, to Kandinsky's Romantic Landscape *in Room 22*

Gabriele Münter, Rapallo, 1906

Vassily Kandinsky at his desk in Ain-millerstrasse, 1913

Alexei Jawlensky, Marianne von Werefkin, Andreas Jawlensky, and Gabriele Münter, Murnau, 1908

flat in Ainmillerstrasse in Schwabing, and in the following year the couple set up house together. During these years, Kandinsky made many international contacts. It was also a period in which his painting met with increasing recognition. He exhibited his paintings and gouaches in Berlin and Paris, where he was strongly influenced by the work of Henri Matisse and by the liberation of colour to become an immediate expressive force, which the Fauves had achieved.

Jawlensky travelled to Normandy and Paris (1903) during the same period, and in 1905, during a stay in Brittany, he made a decisive breakthrough on the path to formal simplification and the intensification of the use of colour. He met Matisse, visited Ferdinand Hodler in Geneva, and discovered the work of Paul Gauguin. The controlled structure of Gauguin's forms, his cloisonnism—areas of colour surrounded by strong outlines—and, in the work of Van Gogh, the intensity of the application of the paint, both in the choice of colour and in the brushwork, were from then on to be of fundamental importance to Jawlensky.

In the late summer of 1908, Kandinsky, Münter, Jawlensky, and Werefkin met in Murnau, a village in the foothills of the Alps south of Munich, and hired accommodation in the Gasthof Griesbräu. There they produced glowing, colourful paintings, mostly landscape studies of immense expressiveness. Enthusiastically taken by the village's picturesque situation, and by the extraordinary artistic stimuli they found there, Kandinsky and Münter returned to Murnau again and again up to the outbreak of the First World War. The very next year, in 1909, Münter bought a house there, on Kandinsky's advice—which soon became known as the 'Russian House' in local parlance. The house became a meeting place for the group of friendly artists who formed the 'Blue Rider' circle. In their search for new forms of expression, it was probably Gabriele Münter who discovered Bavarian folk art here, and encouraged her friends to investigate the effects of simpler, or simplified, forms of expression. For Kandinsky, this opened up a broad field of formal and iconographic significance. Verre églomisé painting, which was then still part of folk art, provided a rich source of inspiration. The artists' attention to folk art, and later to children's art, should be seen in the context of the wider European avant-garde's search for original

Gabriele Münter, The Russian House in Murnau, *linocut, 1931*

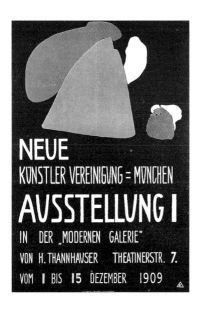

Vassily Kandinsky, poster for the first exhibition of the 'Neue Künstlervereinigung München', coloured lithograph, 1909

expression, which included cultures from outside Europe as well—African sculpture, Polynesian cult objects, and Japanese woodcuts, as well as naïve art and art produced by the mentally ill.

In the months following their stay in Murnau, the artists' collaborative work and frequent contact in Munich also led to the idea that their work might be exhibited on a group basis. On 22 January 1909, the 'Neue Künstlervereinigung München' (New Munich Artists' Association) was entered in the official register of societies and associations. Initially, Kandinsky was its chairman, and later, when tensions between the progressive and moderate members began to emerge, Adolf Erbslöh took over the leadership. Erbslöh was a friend of Jawlensky's, and along with Alexander Kanoldt and the committed art lovers Oskar Wittenstein and Heinrich Schnabel, he had also been a founding member of the 'Neue Künstlervereinigung München'. Over the years, others, such as Paul Baum, Vladimir von Bekhteyev, David Kogan, Pierre Girieud, Karl Hofer, Erma Bossi, also joined. This heterogeneous assemblage

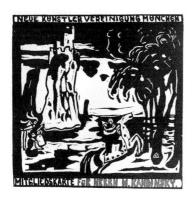

Vassily Kandinsky, membership card for the 'Neue Künstlervereinigung München', showing his woodcut Cliff, *woodcut, 1909*

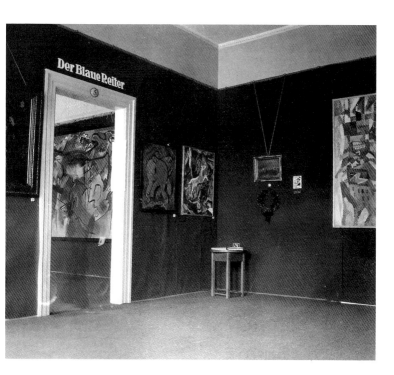

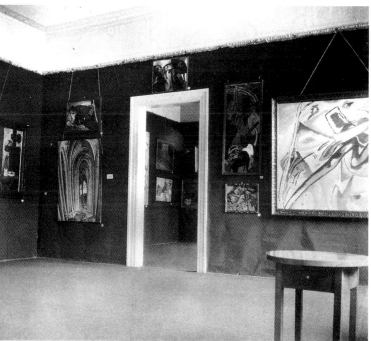

*The first exhibition of the Blue Rider in the Galerie Thannhauser, Munich,
December 1911*

of painters and sculptors represented a fairly broad spectrum of different positions, ranging from Late Impressionism to Symbolism. What united the group—according to the circular printed when it was founded—was 'a search for artistic synthesis', understood to mean artistic unity and a harmonious approach, unity of conception, etc.

From 1 December to 15 December 1909, the Galerie Thannhauser in Munich's Theatinerstrasse exhibited a selection of works by the members of the 'Neue Künstlervereinigung München'. The exhibition was an outstanding success, although it received spiteful criticism in the press; it subsequently travelled to several other locations, and a small catalogue was published.

For the second exhibition, also held in the Galerie Thannhauser, from 1 September to 14 September 1910, international artists were invited, including Georges Braque, André Derain, Kees van Dongen, Henri Le Fauconnier, Pablo Picasso, Georges Rouault, Maurice de Vlaminck, and David and Vladimir Burliuk. For the very first time, Munich was thus able to compare itself face to face with the international avant-garde. Kandinsky was once again largely responsible for setting up contacts for the exhibition, as well as for obtaining contributions to the catalogue. The catalogue included essays by Le Fauconnier, both of the Burliuks, Odilon Redon, and of course also by Kandinsky himself; it consequently acquired the status of a manifesto, and even caused a certain stir in Paris. The second exhibition was also highly successful. While the newspapers stated their rejection of it in no uncertain terms, Franz Marc wrote an enthusiastic report about the exhibition (published by the Association in a special reprint) in which he stated his agreement with the goals of the 'Neue Künstlervereinigung München'.

Franz Marc, born in Munich in 1880, had long hesitated over whether he should become a theologian or an artist. From 1900, he attended courses at the Academy, but soon gave this up again after a visit to Paris during which he encountered the work of Van Gogh and found himself unable to accept the painting style then current at the Munich Academy. At this time, Marc had already identified his central pictorial theme, the depiction of animals. The whole of the natural world, for him, embodied a condition of paradisal innocence. In his earlier years, up to 1909, Marc had principally painted in Lenggries in the foothills of the Alps, with its Alpine pastures and horse paddocks, and later in Sindelsdorf, immediately next to Murnau, where he lived 'surrounded by his models'.

It was a happy coincidence that during a visit to Munich in January 1910, August and Helmut Macke, together with the son of the Berlin collector Bernhard Köhler, saw some of Marc's lithographs at the Kunstsammlung Brakl, and full of enthusiasm decided at once to visit the artist in his studio in Schellingstrasse. The visit led to a close friendship between Franz Marc and August Macke. Macke himself had studied at the academy in Düsseldorf in 1904–5, and, similarly excited by trips to Paris, had oriented himself strongly towards French art. When Macke was staying at the Tegernsee in 1909–10, he met Marc frequently. They soon developed a plan for an exhibition, but they

The Blue Rider rooms: on the left, a view from Room 24 into Room 22; on the following double page, works by Kandinsky in Room 25

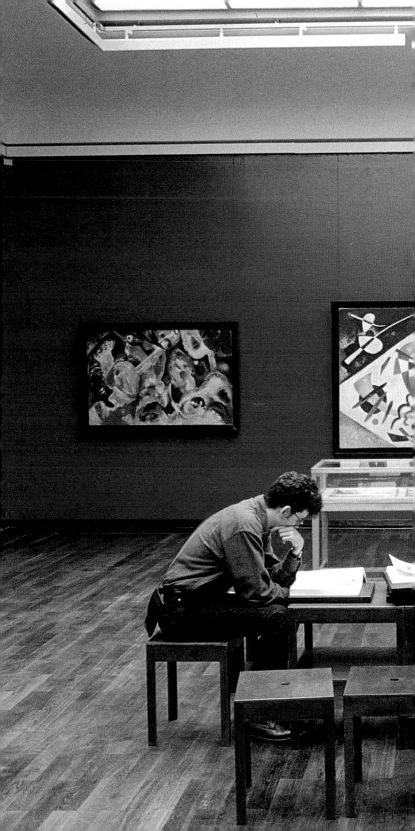

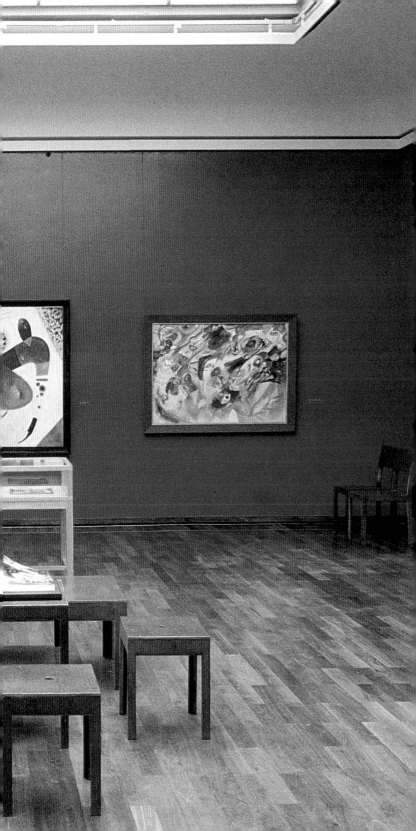

lacked the international contacts they needed to present young avant-garde art. Their encounter with the 'Neue Künstlervereinigung München' and particularly with Kandinsky, therefore, was of immense and momentous significance for Franz Marc and August Macke.

A fundamental aspect of the history of art at the end of the nineteenth century and the beginning of the twentieth century was the frequent occurrence of secessions and splits in artists' associations. What gave the Blue Rider its tremendous significance, however, was the historic intersection represented by the sensation described above that took place in December 1911. It was Kandinsky's path towards non-objective art, or the completion of his first step in this direction, that led to the break with the 'Neue Künstlervereinigung München', showing that even progressive artists recognized that it represented a categorically alien, new position.

The following fourteen artists were represented at the 'First Exhibition by the Editorial Board of *Der Blaue Reiter*' at the Galerie Thann-hauser in December 1911: Henri Rousseau, Albert Bloch, David and Vladimir Burliuk, Heinrich Campendonk, Robert Delaunay, Elisabeth

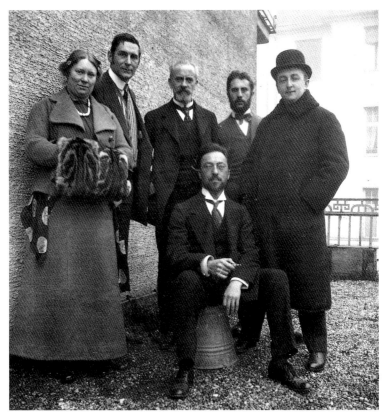

On the terrace of Kandinsky's and Münter's flat in Ainmillerstrasse in Schwabing. Left to right: Maria and Franz Marc, Bernhard Koehler, Kandinsky (seated), Heinrich Campendonk, and Thomas von Hartmann, ca. 1911

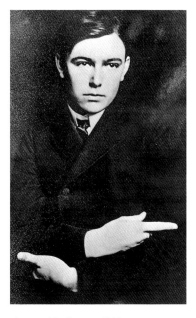
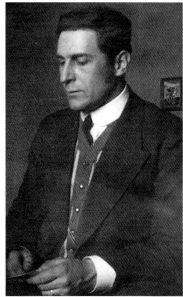

August Macke, ca. 1903 *Franz Marc, Munich, 1911*

Epstein, Eugen von Kahler, Jean Bloé Niestlé, and Arnold Schönberg, in addition to Kandinsky, Macke, Marc, and Münter. As the catalogue stated, it was not a question of 'propagating a precise and particular form, but … of indicating, through the variety of the forms represented, the way in which the artist's inner desire is shaped in a multiplicity of ways'.

The second Blue Rider exhibition was held in February 1912, only a few months later, and took place the Kunsthandlung Goltz. Graphic works were shown: some 300 watercolours, drawings, woodcuts, and etchings. It included work by the artists of the group 'Die Brücke' ('The Bridge')—Erich Heckel, Ernst-Ludwig Kirchner, Otto Müller, Emil Nolde and Max Pechstein, as well as work by international artists such as Georges Braque, Pablo Picasso, Maurice Vlaminck, Natalia Goncharova, Mikhail Laryonov, Kasimir Malevich, and others.

It was clear to the pragmatist Kandinsky that the journalistic propagation of their new ideas was almost as important as the presentation of work in the exhibitions. During the summer of 1911, probably for the theoretical reasons discussed in his book *Concerning the Spiritual in Art*, Kandinsky developed the idea of producing an art almanac. He first mentioned it in a letter to Franz Marc of 19 June 1911. This was the real moment of birth of the Blue Rider, even though the actual publication only appeared in May 1912.

A report by Kandinsky from 1930 survives concerning the way in which the title was chosen. Looking back, he ironically simplifies the process by saying, 'We came up with the name *Der Blaue Reiter* at the coffee table in the summerhouse at Sindelsdorf. We both liked blue; Marc liked horses, I liked riders.' Horse and rider—romantic notions about animals and a belief in the nobility of the spirit had certainly

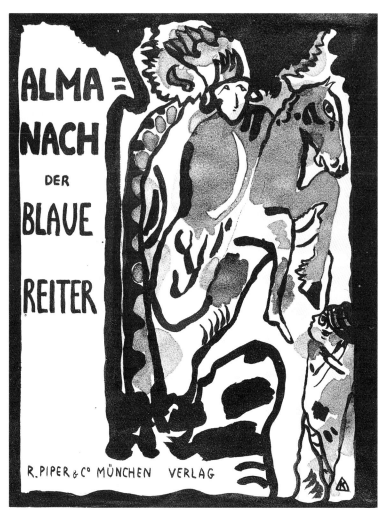

Vassily Kandinsky, final sketch for the cover of the almanac Der Blaue Reiter, *watercolour, 1911*

been a thematic emphasis in the work of both of the artists prior to this, and a variety of symbolic interpretations had been attached to them. Blue, the colour of the sky, may have included overtones of the romantic notion of the blue flower (the central symbol in Novalis's novel fragment 'Heinrich von Ochterdingen').

A notable characteristic of the almanac *Der Blaue Reiter*, which Kandinsky and Marc put together with tremendous enthusiasm from the summer of 1911 onwards, is its far-reaching intellectual openness towards new pictorial sources; at the same time, there is an explicit confrontation with a very broad range of traditional art, although in resolute resistance and opposition to the academic practices of the period. Kandinsky even considered the idea of including further phenomena,

Paul Klee, Munich, 1911

such as advertising, kitsch, and photography, in a second volume, which was never published.

The almanac includes texts written by the two editors, Marc and Kandinsky, as well as by David Burliuk, Macke, Schönberg, Thomas von Hartmann, and Roger Allard. Kandinsky's contributions, of course, are particularly prominent, and it was here that he published his essays on 'The Question of Form', 'Stage Composition', and 'The Yellow Sound'. A general keynote can be seen in the repeated mention of the idea of the total work of art being as an expression of comprehensive renewal. The phrase 'the spiritual in art' is evident throughout Kandinsky's writings, the gradual extraction of the spiritual and intellectual element from existing objective circumstances, the release of motifs into a non-objective form of depiction—a process in which there are clear parallels to theosophy and to turn-of-the-century irrationalism.

The dramatic caesura in the European pictorial tradition that took place at the beginning of this century is therefore documented in the almanac *Der Blaue Reiter* in various ways. Associated with this, hopes were placed in an approaching 'epoch of the grand intellect', from which a new form of art might arise, one that would be capable of fusing literature, music, and the fine arts into one.

However, at the moment when Kandinsky took the first step towards abstraction, the break with other artists who also considered themselves progressive became evident. Collectors turned away from him, and criticism of his work became ferocious and unpleasant, describing his painting as 'idiotic'. However, just as Marc had shown a strongly positive reaction to the 'Neue Künstlervereinigung' exhibition that had been rejected by the critics, Paul Klee—one of Kandinsky's immediate neighbours in Munich—similarly now discovered his affinity with him.

The two exhibitions, and the publication of the almanac *Der Blaue Reiter*, briefly catapulted Munich into the limelight of the international

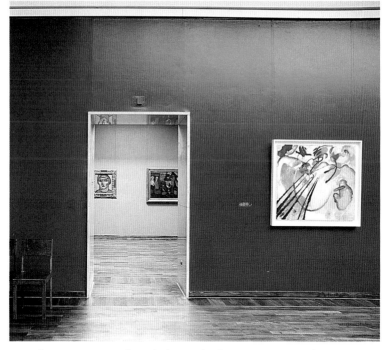

View from Room 25, with works by Kandinsky, towards pictures by Jawlensky and Münter in Room 24

artistic avant-garde. However, when the First World War broke out, and with the early deaths on active service of August Macke and Franz Marc and the expulsion from Germany of Kandinsky, Jawlensky, and Werefkin, this promising scene was destroyed at a single stroke.

Pages 44–5: view from Room 24, with works by Jawlensky and Münter, towards the Kandinsky room, Room 25

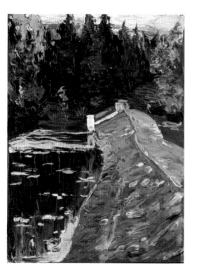

Vassily Kandinsky (1866–1944)
Study for a Weir, 1901
Oil on cardboard, 31.6 x 23.9 cm
During his early years in Munich, Kandinsky painted numerous landscapes. At this period, he worked on small pieces of cardboard, which allowed him to manage without an easel. Some of his studies from the period around and shortly after 1900 are almost reminiscent of his later, Fauve-influenced palette. In the *Weir*, the pointillist procedure of Late Impressionism can be seen behind the intensity and immediacy of the way in which the paint is applied using the spatula. The influence of Art Nouveau, even at this early period, is also clear.

Vassily Kandinsky (1866–1944)
Beach Chairs in Holland, 1904
Oil on canvas, 24 x 32.6 cm
The 'little oil studies' that Kandinsky painted on his many walks clearly show the way in which his early work developed out of traditional painting. The lively structure of the impasto application of the paint, as well as the depiction of a specific landscape atmosphere, both recall Impressionism here. With the meagreness of its artistic techniques, which are restricted to a few brushstrokes and a few swabs of the spatula, allowing the structure of the canvas to contribute its effects throughout, *Beach Chairs in Holland* has a particularly unconventional attractiveness.

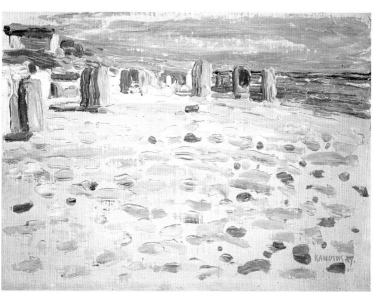

Vassily Kandinsky (1866–1944)
On the Edge of Town, 1908
Oil on cardboard, 68.8 x 49 cm
After their first stay in Murnau,
where they regularly spent several
weeks every year from their return
to Bavaria in 1908 until the out-
break of the First World War, Vas-
sily Kandinsky and Gabriele Mün-
ter entered a phase of extreme
productiveness and rapid artistic
progress. One of the first pictures
of this period is this view, painted
with an energetic movement and
extremely intense colours, of
Kandinsky's new surroundings in
Schwabing on the edge of the old
city of Munich. The influence of
the Fauves is clear.

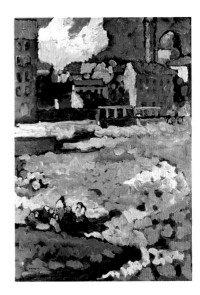

Vassily Kandinsky (1866–1944)
**Cemetery and Vicarage in
Kochel**, 1909
Oil on cardboard, 44.4 x 32.7 cm
Working in Murnau, where they
were joined by Alexei Jawlensky
and Marianne von Werefkin,
meant for Kandinsky and Münter
above all that they had been freed
from their years of experimenta-
tion and had made the decisive
breakthrough towards finding
their own means of artistic expres-
sion. The transformation in Kan-
dinsky's work towards this new
approach and towards newly de-
veloped forms can clearly be seen
in the abundance of his landscape
paintings. *Cemetery and Vicarage
in Kochel* was produced in Feb-
ruary 1909 during a stay in
Kochel, near Murnau. In the win-
ter paintings of that year, with
their unreal alterations in colour
and form, Kandinsky experiment-
ed again and again with new ways
of escaping from the realistic view
of nature.

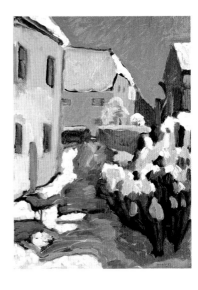

Gabriele Münter (1877–1962)
Crosses in the Cemetery in Kochel, 1909
Oil on cardboard, 40.5 x 32.8 cm
Gabriele Münter painted this picture during a visit to her friend, the musician and composer Thomas von Hartmann, in Kochel in February 1909—when Kandinsky's *Cemetery and Vicarage in Kochel*, among other works, was also produced. There is a notable similarity between the two paintings, since both were painted from nature in the open air. Münter's and Kandinsky's work was never as close as it is in these landscape studies.

Vassily Kandinsky (1866–1944)
Railway near Murnau, 1909
Oil on cardboard, 36 x 49 cm
In the late summer of 1909, Münter purchased a house near Murnau, at Kandinsky's insistence, which soon became known as the 'Russian House' in local parlance. In *Railway near Murnau*, Kandinsky records the daily view of the train steaming past on the line between Munich and Garmisch, which ran close alongside their grounds. It is one of the few paintings by him that have modern technology as their subject, although the naïve, almost humor-

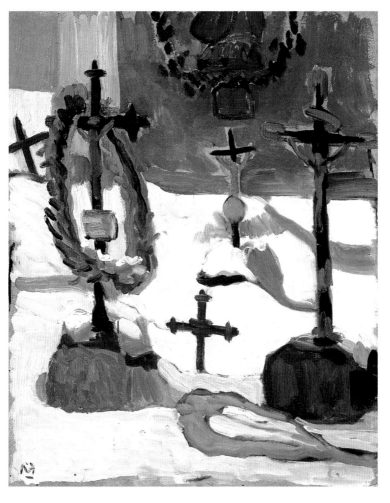

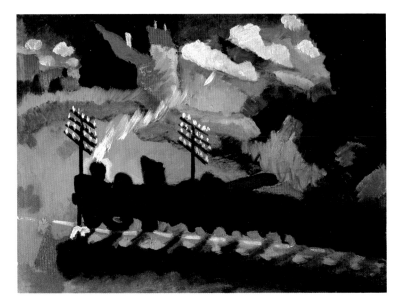

ous treatment of the small railway, with the train apparently moving by magic, is noticeable. The influence of naïve folk art and verre églomisé painting, which the artists had recently discovered, can also be seen here.

Vassily Kandinsky (1866–1944)
Nature Study near Murnau III, 1909
Oil on cardboard, 31.5 x 44.7 cm
Kandinsky painted views of Murnau, with its church, colourful roofs, and the jutting gable of the medieval castle, again and again, seen from the window of the house that he shared with Gabriele Münter. The principal interest here is obviously the power of the colours, the dark mixture of colours in the autumn landscape. The cutting off of the horizon at the upper edge of the picture subdues the impression of perspective, of illusionistic spatial extension. The appearance of the landscape and its expressiveness are created purely by the spontaneous flow of the brushstrokes and the tone of the colours.

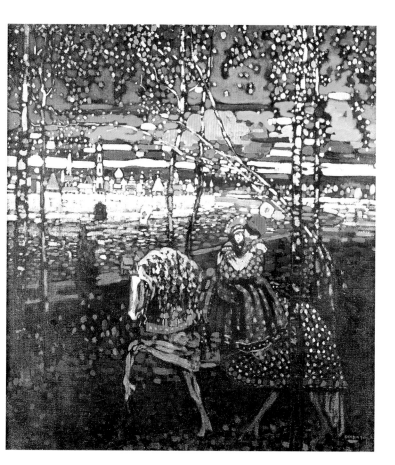

Vassily Kandinsky (1866–1944)
Couple on Horseback, 1906–7
Oil on canvas, 55 x 50.5 cm
The *Couple on Horseback* belongs
to the large group of Kandinsky's
early paintings in which he con-
jures up a poetic world of images,
full of enigmatic variety, using fai-
ry-tale, freely imagined scenery. As
well as groups of Biedermeier fi-
gures and the medieval knights in
an old German *ambiance*, he was
particulary fascinated by old Rus-
sian subjects. Here, too, the couple
are riding in Russian costume,
with the silhouette of a town with
a kremlin in the background. The
symbolism was just as important
to the conception and poetic qual-
ity of the image as the over-refined
aesthetics of Art Nouveau were.
The achievements of neo-Impres-
sionism involved the subdivision
of the object's colouring and the
pointillist placement of individual
colour elements. Even at this level,
the way in which Vassily Kandins-
ky used colour as a means of dis-
guising the painting's content be-
comes clear. This is one of the
most important aspects of his
artistic approach. In one of his
early notes for the book *On the
Spiritual in Art*, Kandinsky wrote,
'The wealth of colour in the pic-
ture must be powerfully attractive
to the viewer and at the same time
conceal the deeper content.'

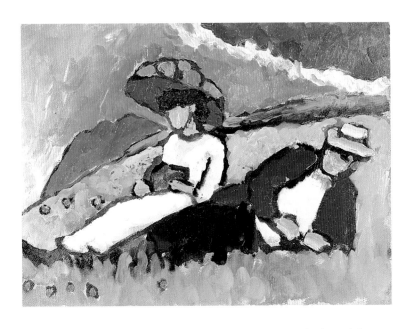

Gabriele Münter (1877–1962)
Jawlensky and Werefkin, 1908–9
Oil on cardboard, 32.7 x 44.5 cm
For Gabriele Münter, as well as for
Vassily Kandinsky, the discovery of
the area around Murnau signified
a decisive change in her artistic
development. This small oil study
of Jawlensky and Werefkin, show-
ing the couple, both painters, lying
in a meadow in the mountains,
was produced during one of their
joint visits to Murnau in 1908 or
1909. It impressively demonstrates
the change in style adopted by
Münter—the sudden daring, un-
compromising independence and
the emphasis on reduced outline
drawing, in contrast to her earlier
painting studies in nature, which
had been based on the tradition of
Late Impressionism. Radical
simplification of forms and clear,
powerful colour contrasts charac-
terize the painting. All of the im-
portant elements are set tersely
and accurately in powerful black
contours, using a cloisonnist tech-
nique that she had learned from
Alexei Jawlensky—and which was

therefore ultimately derived from
Paul Gauguin.

Alexei Jawlensky (1864–1941)
Summer Evening in Murnau,
ca. 1908–9
Oil on cardboard, 33.2 x 45.1 cm
In the economy of its graphic
means, the intense colouring, and
the use of black contours, Jawlen-
sky's *Summer Evening in Murnau*
shows considerable similarity to
Münter's landscape paintings of
the same period. In the reduction
of the landscape to a few loose
areas, only characterized by a few
sparing details, Jawlensky's con-
cept of painterly 'synthesis', which
Münter described as 'deriving an
extract', is particularly clear.

Alexei Jawlensky (1864–1941)
Murnau Landscape, 1909
Oil on cardboard, 50.4 x 54.5 cm
Pictures such as *Murnau Land-
scape* are evidence that Jawlensky,
during the phase in 1908–9 when
working together with Münter in

Murnau, was for a time the most progressive of the four artist friends. The reduction of the landscape to geometric, angular areas creates a high degree of stylization, in which the colours depart from those found in nature with a daring never demonstrated before, and both the objects and their shadows are seen as glowing coloured surfaces. The angular, distorted shapes in the picture are influenced by French Cubism, particularly by Le Fauconnier, who along with others was invited to take part in the second exhibition by the 'Neue Künstlervereinigung München'.

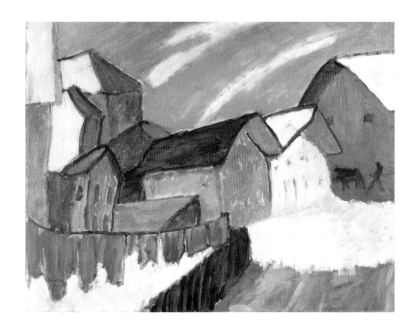

Gabriele Münter (1877–1962)
Village Street in Winter, 1911
Oil on cardboard, mounted on
wood, 52.4 x 69 cm
This highly coloured picture
powerfully expresses the simplicity
and directness of Münter's artistic
talent, in addition to her radical-
ness. In areas clearly marked off
from one another, glowing, ap-
parently unnatural colours are im-
mediately juxtaposed. The slant-
ing, tilted buildings, accentuated
by energetic black contours, give
the motif dynamism and 'deform'
it from the artist's subjective point

of view. 'Conciseness' of the artistic means dominates here as well, although in a different way from the work of Kandinsky.

Gabriele Münter (1877–1962)
Murnau Peasant Woman with Children, ca. 1909–10
Verre églomisé painting,
21.5 x 19.5 cm
Gabriele Münter and Vassily Kandinsky were full of enthusiasm for the childlike simplicity of the depictions, the plain drawing, and the glowing colouring in the Murnau glass painters' folklore pictures. The couple's comprehensive collection of folk art includes, among other items, numerous verre églomisé pictures, which decorated the walls of their flat in Ainmillerstrasse. Gabriele Münter was probably the first in the group who also began to use this technique herself. The pretty, colourful results stimulated the others to try it as well, and all of them—Marc, Macke, Kandinsky, and even Klee—painted in verre églomisé.

Gabriele Münter (1877–1962)
Dark Still Life (Secret), 1911
Oil on canvas, 78.5 x 100.5 cm
In the eventful years from 1910 to 1912, Münter developed the narrow spectrum of her subjects—landscapes, still lifes, floral pieces—to full maturity. The still lifes, in particular, into whose arrangement tiny figures were now often incorporated, acquired their own unmistakable note at this period. Münter used as her models the small sculptures, religious woodcarvings, and craft objects from the collection of folk art that she and Kandinsky had assembled during their Murnau years. The *Dark Still Life (Secret)* can be identfed from a photograph as part of the flat they shared in Ainmillerstrasse in Munich.

Marianne von Werefkin
(1860–1938)
Self-Portrait, 1910
Tempera on cardboard,
51 x 34 cm
When she turned fifty, Mariane von Werefkin was portrayed and painted on several occasions. Because of her temperament and charisma, she was almost always shown as a young woman. In her self-portrait from this period, she depicts herself as a woman who in the course of life has experienced, thought, and suffered a great deal. The interest in the self-portrait centres on the eyes, mirrors of her spirit—of her mind. What is remarkable is the clarity and consistency of the use of purely Expressionist means, i.e. the colour, while all attributes and accessories are abandoned.

Gabriele Münter (1877–1962)
Portrait of Marianne von Werefkin, 1909
Oil on cardboard, 81 x 55 cm
Münter painted this portrait of her artist friend in 1909, at the peak of the period when they were

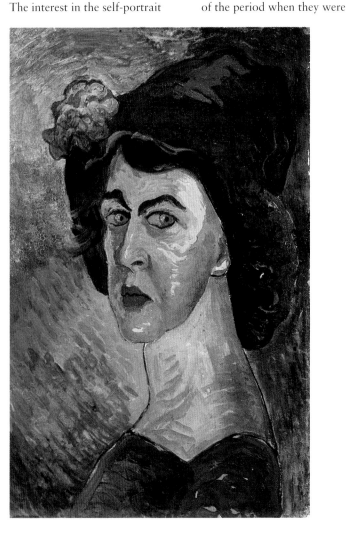

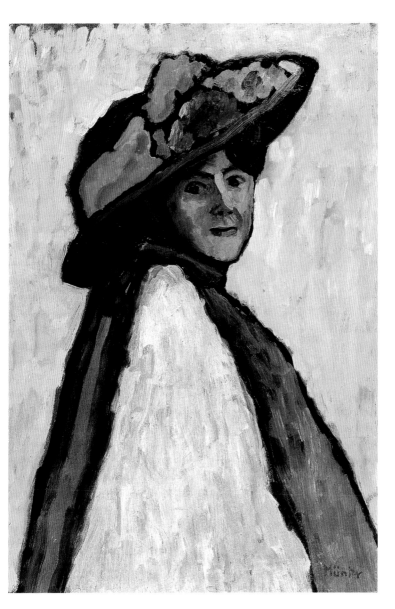

working together. The salon that was led by Jawlensky and Werefkin in Giselastrasse in Schwabing was the meeting point for the group of artists in the 'Neue Künstlervereinigung München', founded in January of that year. The hostess was always the social focus of these evenings. The daughter of a general, she had met Jawlensky after studying painting in St. Petersburg, and moved to Munich with him. Although she soon largely put aside her own painting in order to devote herself entirely to Jawlensky's talent, she remained an outstanding figure in the circle of artists, not least due to her contributions to discussions on the theory of art.

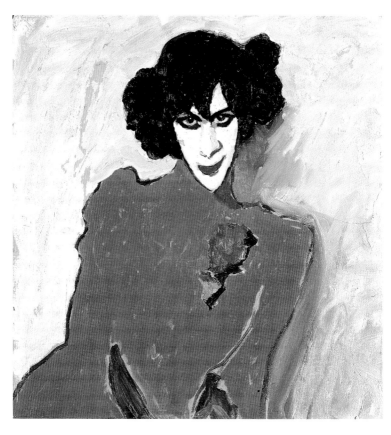

Alexei Jawlensky (1864–1941)
**Portrait of the Dancer
Alexander Sakharov**, 1909
Oil on cardboard, 69.5 x 66.5 cm
This is the first portrait by Jaw-
lensky showing the motif of a
frontally viewed, symmetrically
structured portrait figure with
wide-open eyes and a penetrating
gaze, which was to become a cen-
tral theme in his pictures, with in-
creasingly stylized heads, up to the
First World War. Jawlensky paint-
ed several portraits of the ballet
dancer Sakharov, who was then a
close friend. This painting was
produced spontaneously in less
than half an hour, when the dancer
visited the painter in his studio one
evening before a performance,
already made up and in costume.
Sakharov's androgynous quality
must have been particularly at-
tractive to Jawlensky, who in his
later series of 'Heads' increasingly
obliterated all individual and sex-
specific characteristics from his
pictures in favour of a schematic,
meditative view of the human
face.

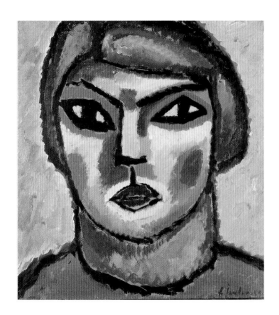

Alexei Jawlensky (1864–1941)
Maturity, ca. 1912
Oil on cardboard, 53.5 x 49.5 cm
Maturity marks a notable transformation in Jawlensky's depiction of the human face. The strictly frontal view, the imploring gaze from large, black-bordered eyes, and the loud, bright colours restrained by a solid black lineal structure, make the de-individualized facial characteristics rigidify into an idol-like mask. The stylization, the simplification of the motif, and the formal concentration anticipate the mystical 'Heads' that Jawlensky was to produce from 1917 onwards.

Alexei Jawlensky (1864–1941)
Love, 1925
Oil on cardboard, 59 x 49.5 cm
This quite large picture can be seen as one of the principal works of the 1920s among Jawlensky's 'Constructive Heads'. The motif carries on from where the earlier 'Mystical Heads' and 'Saints' Faces' left off, while the geomet-

rical precision and solidity have parallels in the contemporary work of other artists. In the mid-1920s, Jawlensky had united his former colleagues Kandinsky, Klee, and Feininger to form an association known as the 'Blue Four', which principally concerned itself with exhibiting and marketing the members' work. In terms of its artistic aims, however, the group had little influence on Jawlensky.

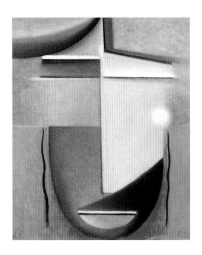

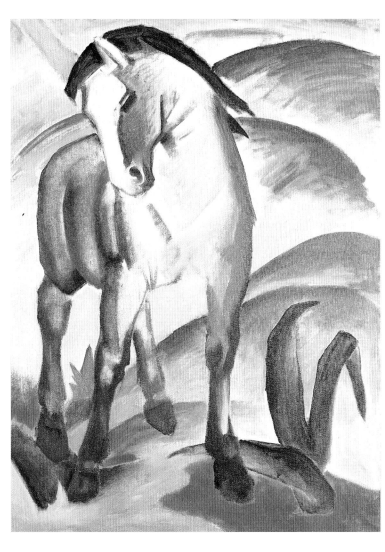

Franz Marc (1880–1916)
Blue Horse I, 1911
Oil on canvas, 112 x 84.5 cm
With its insistent symbolic power, and in its transfiguration by the excitement of a new era, the *Blue Horse* has become one of the best-known works by Franz Marc and by the Blue Rider group as a whole. The painting illustrates, in an unusually pure way, Marc's colour theory, which is decisive for many of his works: ' "Blue" is the "male" principle, austere and in-tellectual. "Yellow" is the "fe-male" principle, gentle, cheerful, and sensual. "Red" is "matter", brutal and heavy and always the colour that has to be fought by the other two and overcome!' The role of the colour blue as a symbol of the spiritual and intellectual, of victory over the material element, is clearly expressed here. The nob-ility of the horse, an animal which has always been highly valued by human beings, is linked to the striving for the spiritual and in-

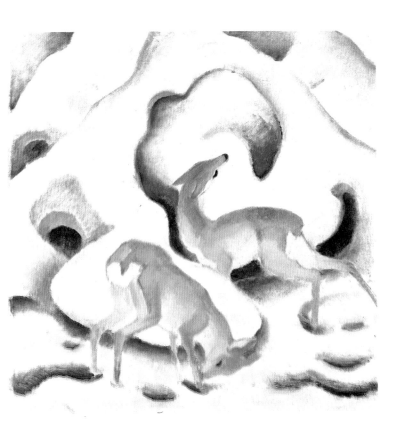

tellectual—corresponding to the programme to which Kandinsky, too, had devoted himself, with his symbolic figure of the Blue Rider on the title page of the famous almanac. Formally, too, however, the horse is intensified to an emotional and expressive level. Holding its stance with lowered head, it gives the viewer the impression of being a sentient creature. Evidence can readily be found that Marc based many of his portrayals of animals on the postures and compositional patterns seen in traditional depictions of the human figure. In this manner, he attaches human characteristics and attributes to the animal.

Franz Marc (1880–1916)
Deer in the Snow, 1911
Oil on canvas, 84.7 x 84.5 cm
Deer in the Snow is one of the first works in which Franz Marc departs from the naturalism of his previous depictions of animals, and turns decisively away from a realistic description of nature. The well-thought-out interplay between the formal relationships, and the swung rhythms of the animals and the landscape within a closed, triangular composition, create here for the first time an independent order that transcends mere accident and conjure up a vision of harmony between creation and the creatures within it.

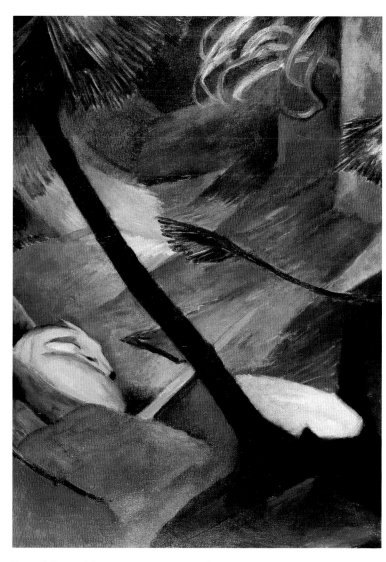

Franz Marc (1880–1916)
Deer in the Forest II, 1912
Oil on canvas, 110 x 81 cm
As early as April 1910, Franz Marc moved permanently to Sindelsdorf, near Murnau, and he subsequently devoted himself almost exclusively to the depiction of animals. In the summer of 1911, he painted the first version of *Deer in the Forest*. The following year, this second version was produced, in which all of the individual forms are more strongly elaborated, and the expressive diagonal of a black tree trunk is interposed in front of the enigmatic depths of the nocturnal fairy-tale forest, glowing with colours. Nature seems to be viewed here from its own centre—through the eyes of the animal itself.

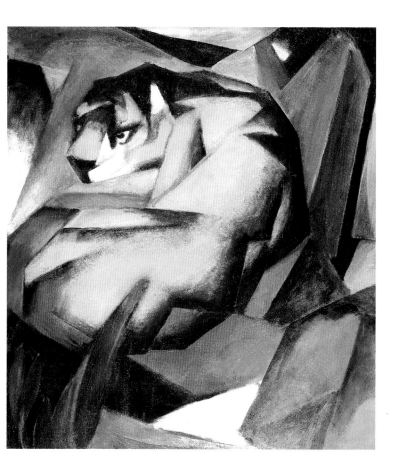

Franz Marc (1880–1916)
The Tiger, 1912
Oil on canvas, 111 x 111.5 cm
The Tiger is one of the principal
works of Marc's mature period,
produced before he came under
the influence of Robert Delaunay
in his 'late work' of 1913–14 and
developed an even more extensive
formal interplay between abstract
rhythmic strips and blocks of
colour. Despite the tendency to-
wards abstraction here, the essence
of the predator is grasped with the
greatest possible precision, and
condensed into its essential form.
The painting is the fruit of the
many years of effort which Marc
devoted to grasping animals ana-
lytically in their typical postures,
thus advancing into the core of
their being.

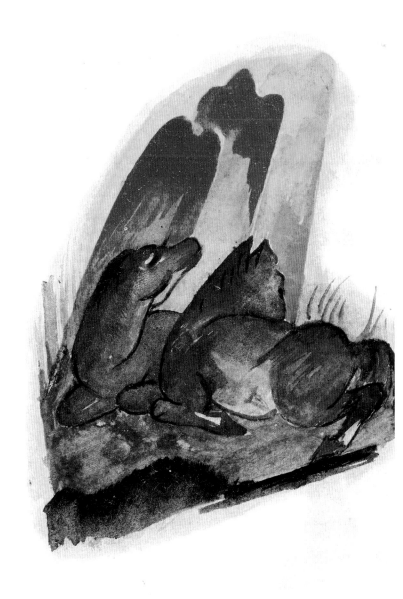

Franz Marc (1880–1916)
Two Blue Horses in Front of a Red Cliff, 1913
Tempera, varnished, 14 x 9 cm
This postcard to Vassily Kandinsky, like many of the painted postcard greetings that Marc sent to Else Lasker-Schüler, is an incuna-bulum of the world of his artistic imagination. What Marc called the 'yearning for indivisible being' is given pictorial form in the foals resting peacefully side by side on the grass. The text, however, prosaically enough, concerns arrangements for a meeting.

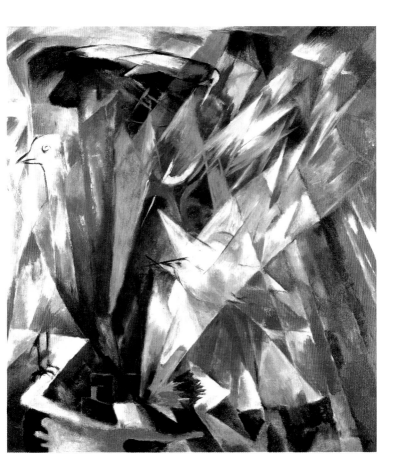

Franz Marc (1880–1916)
Birds, 1914
Oil on canvas, 109 x 100 cm
The painting, in which the flapping of the three birds' wings seems magically to have been brought to a standstill, reflects Marc's study of Futurism and the work of Robert Delaunay. It shows the way in which, at the end of his creative life, he increasingly used non-objective forms, eliminating objects—the logical consequence of his effort to achieve a renewal and purification of art, in which he ultimately even saw the 'innocent' animal as being an 'impure' and disturbing element. The world appears as a crystal, through which the light is refracted.

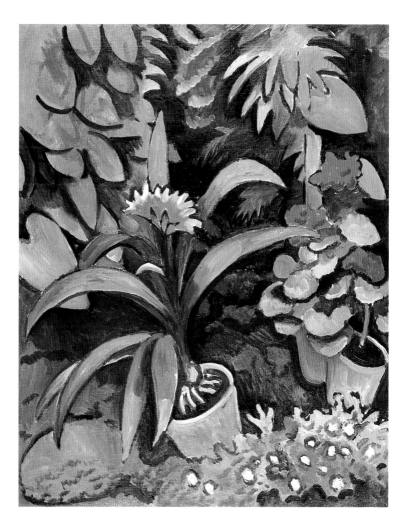

August Macke (1887–1914)
Flowers in the Garden, Clivia and Geraniums, 1911
Oil on canvas, 90 x 71.5 cm
The works Macke produced in 1911 reflect a wide variety of artistic influences, and *Flowers in the Garden* is a final intensification of his 'Fauve phase' and his study of Matisse. What is actually an uncomplicated detail from nature, in the artist's garden in Bonn, takes on an almost oppressive shape in this still life, through the intensity of the pure colours. According to the artist himself, he was more and more concerned with 'finding the space-forming energies of colour'.

August Macke (1887–1914)
Zoological Garden I, 1912
Oil on canvas, 58.5 x 98 cm
Zoological Garden I is one of Macke's best-known works. The masterly composition of the painting presents one of the first supreme achievements in the treatment of a complex of subjects that was to become Macke's very own

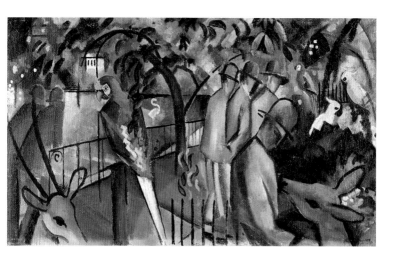

field: the silent world of 'modern paradises', the world of strollers, newspaper readers, people in garden restaurants, in front of shop windows, people relaxing idly on beach promenades. The new motif of the zoological garden occurred to Macke for the first time during a visit to Amsterdam in the spring of 1912. He made numerous sketches in Holland and in the zoo in Cologne as well, and subsequently based several paintings on these works.

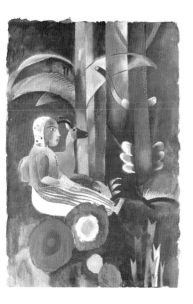

Heinrich Campendonk
(1889–1957)
Forest, Girl, Goat, 1917
Oil on canvas, 94 x 64 cm
It was his admiration for Franz Marc and his work that prompted Heinrich Campendonk to move from the Rhineland to Upper Bavaria in 1911. His consequent entry into the Blue Rider circle and participation in their first exhibition in December 1911 was a milestone in his artistic development. His acquaintance with Kandinsky and friendship with Paul Klee were tremendous stimuli for the development of his artistic talents. Campendonk described the years of simple village life in the Upper Bavarian landscape that he spent with the group of artists as having been the happiest period of his life.

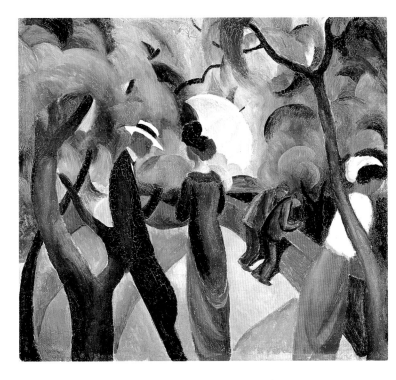

August Macke (1887–1914)
Promenade, 1913
Oil on cardboard, 51 x 57 cm
In his pictures of strollers at a
lakeside, many of which were pro-
duced in Hilterfingen, Macke is
seen at the peak of his talents. The
immense magic of his art, the way
in which it is suspended between
visual pleasure based on purely
optical considerations and a quiet
immersion in the figure, emerges
in a masterly fashion in these
sparkling park landscapes, in
which the strollers seem to have
paused for a moment, lost in re-
verie.

August Macke (1887–1914)
Turkish Café, 1914
Oil on wood, 60 x 35 cm
In April 1914, Macke travelled to
Tunisia together with Paul Klee
and Louis Moilliet. Under the in-
fluence of the southern light and
the intense effect of the colours,
his art underwent a final intensi-
fication. He returned from Tunis
with an abundance of water-
colours and sketches. He later
executed *Turkish Café* in Bonn
in two versions; he presented this
one to Bernhard Koehler, who
had provided financial support
for the trip.

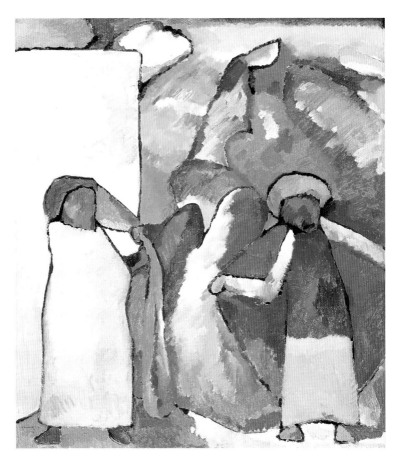

Vassily Kandinsky (1866–1944)
Improvisation 6 (African), 1909
Oil on canvas, 107 x 95.5 cm
The clear compositional arrange-
ment and precise definition of in-
dividual elements are what distin-
guish this painting from the other
'Improvisations'—in Kandinsky's
own definition, 'impressions of in-
ward nature'—of this period. The
subject is certainly based on im-
pressions gathered during the trip
to Tunis which Kandinsky made
with Gabriele Münter at the begin-
ning of 1905, and which he had in-
corporated into an abundance
of sketches and 'colour drawings'.
Even in this comparatively less
abstract, objectivizable 'Improvisa-
tion', however, Kandinsky is ob-
viously seeking to conceal the ob-
jects to some extent, so that their
'inner note' can be heard alongside
the outward, objective motif.

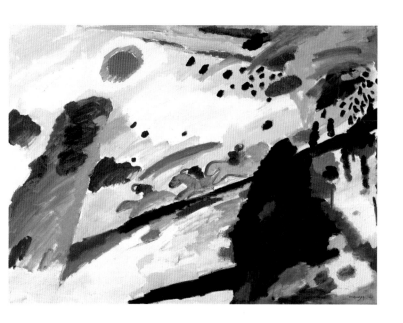

Vassily Kandinsky (1866–1944)
Romantic Landscape, 1911
Oil on canvas, 94.3 x 129 cm
The 1911 work *Romantic Lands-cape*, described by Kandinsky neither as an 'Impression' nor as an 'Improvisation', is not a purely landscape depiction, but forms a category of its own. While its form is breathtakingly open and spontaneous, its process of pictorial discovery retains its hermetic, magical quality. The impression of movement and immediacy derives principally from the three riders rushing down the slope from right to left.

Vassily Kandinsky (1866–1944)
Impression III (Concert), 1911
Oil on canvas, 77.5 x 100 cm
This painting was produced shortly after a concert of works by Arnold Schönberg, which Kandinsky attended with Marc and other members of the 'Neue Künstlervereinigung München' on 2 January 1911. Kandinsky described the picture as an 'Impression', as a 'direct impression of "external nature" ', by which he meant sensory impressions of all sorts. *Impression III (Concert)* is based on an acoustic experience, and represents the translation of this into the form of painting. On closer inspection, the painting can be seen to catch the essence of the concert experience: one can see the black concert grand piano and the bent backs of the members of the audience in front of it. Kandinsky seems to have particularly associated the colour yellow with musical experiences; a sketch for a stage play with music of 1909 was later published in the almanac as *The Yellow Sound*.

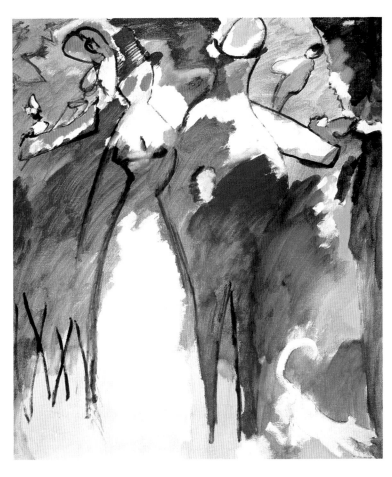

Vassily Kandinsky (1866–1944)
Impression IV (Sunday), 1909–10
Oil on canvas, 107.5 x 95 cm
The picture radiates something of the atmosphere of an idle bourgeois weekend stroll. An elegant couple in their Sunday clothes are walking towards the viewer, preceded by a small white dog, and behind them there is a blurred backdrop of a park in which one might be able to make out a child on a swing, among other things. Although they are only hinted at in outline, the couple's costume suggests the Belle Epoque at the end of the nineteenth century—a period that Kandinsky had used to characterize his figural subjects even at the beginning of his artistic development. What is noticeable here is the reduction of the figures to a framework of more or less powerful black contours, most of them being mere outlines. The lack of clarity in the subjective perception, typical of the series of 'Impression' pictures, disembodies the figures and makes them permeable to autonomous colours. In this way, the figures fuse with their surroundings, but without actually ceasing to exist themselves. They continue to act as graphic ciphers, and in Kandinsky's sketches from 1911 on, these increasingly become emancipated into independent elements.

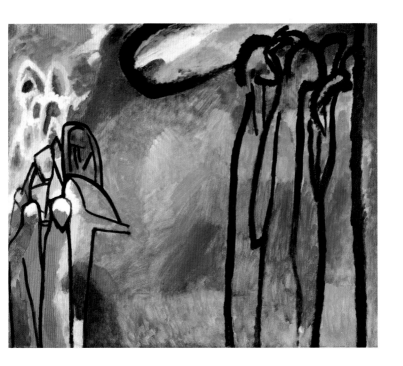

Vassily Kandinsky (1866–1944)
Improvisation 19, 1911
Oil on canvas, 120 x 141.5 cm
More than any of the other 'Improvisations' presented here, *Improvisation 19* illuminates a further aspect of Kandinsky's emancipation from the traditional pictorial object. In the years preceding the First World War, he concerned himself intensively with philosophical and mystical ideas. The new field of depth psychology and related sciences at the beginning of the twentieth century opened up for him new potentials for perception and design which matched his striving to find a way of expressing what was immaterial. Kandinsky was concerned here with the pictorial materialization of elements that only existed spiritually: transparent, black-bordered figures seem to have been drawn under the spell of unknown events, illuminated by colour phenomena, auras, which penetrate people as expressions of states of mind and emotion and which radiate out from them.

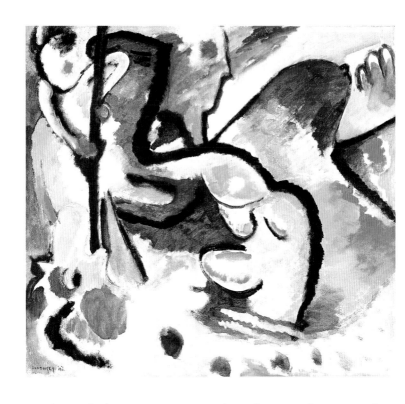

Vassily Kandinsky (1866–1944)
St George III, 1911
Oil on canvas, 97.5 x 107.5 cm

Alongside the Christian motifs of 'All Saints' Day' and the 'Last Judgement', which entered Kandinsky's symbolic vocabulary around 1911, the figure of St George—the Christian dragon-slayer and victor over evil—took on a centrally important role for him at around the same time. He devoted a series of pictures to the Christian knight. The figure of the saint is hardly recognizable here, veiled by the dominant use of colour, particularly white, which Kandinsky uses for the 'translation of nature' into an 'inner impression'. The formal structure of the painting becomes a secondary conveyor of significance, one that is almost more important than the motif.

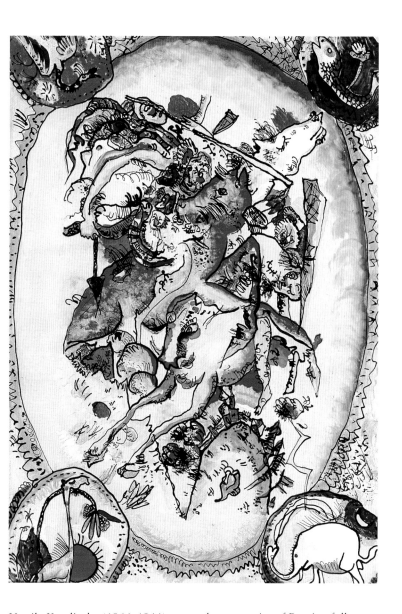

Vassily Kandinsky (1866–1944)
Horseman of the Apocalypse II,
1914
Verre églomisé painting,
30 x 21.3 cm
It was not only the influence of Bavarian folk painting in verre églomisé and in votive images, but also memories of Russian folk art and sources in old German woodcuts—Dürer's *Apocalypse*—that inspired Kandinsky in this verre églomisé work. The motif of the horseman of the Apocalypse is symptomatic of his range of subjects prior to the First World War.

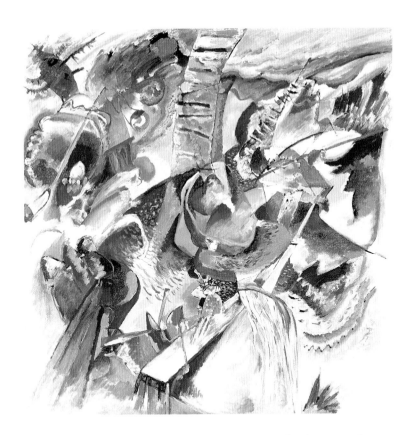

Vassily Kandinsky (1866–1944)
Improvisation Klamm, 1914
Oil on canvas, 110 x 110 cm
Out of the collapsing confusion, which conveys an impression of disturbed natural phenomena, small, graphically fine elements crystallize on closer inspection, and their figural realism at this stage of Kandinsky's painting is surprising: a couple in Bavarian costume on a landing-stage, boats, sunset over blue water. With a schematic suggestion of one of the Horsemen of the Apocalypse on the left edge of the picture, who is brandishing a balance and a pair of scales above his head, the painting fits into the doom-laden fantasies that are characteristic of Kandinsky's paintings prior to the First World War.

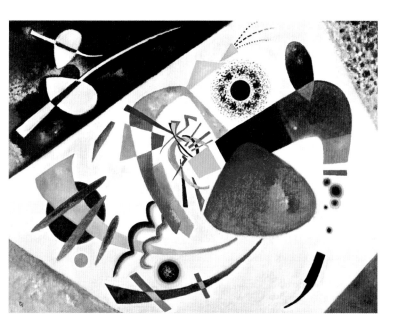

Vassily Kandinsky (1866–1944)
Red Patch II, 1921
Oil on canvas, 131 x 181 cm
On the outbreak of the First World War, Kandinsky returned to Russia. *Red Patch II*, with the fundamental change in the form of expression, marks the beginning of a new phase in his painting, which had virtually ceased altogether during the years of war and revolution. The violent expressive force of his earlier paintings has now given way to a cool, apparently rational compositional scheme of pure individual forms. The precise bodies and surfaces, the geometrical division of the pictorial elements, and the smooth application of the paint, would not be conceivable without some contact with Russian Constructivism, although Kandinsky had always distanced himself from it. The additive collocation of the elements in Kandinsky's painting also distinguishes it clearly from the logical and constructional arrangements seen in Constructivism.

Robert Delaunay (1885–1941)
Window on the City, 1914
Wax crayon on carton,
24.8 x 20 cm
The process of abandoning the object and of restructuring the means of artistic expression seen in the work of the Frenchman Robert Delaunay, who also took part in the first Blue Rider exhibition, was clearly recognized and enthusiastically received by his German colleagues. The great series of 'Window Paintings', produced from 1912 on, represented a breakthrough for Delaunay towards new methods of artistic design. In the paintings, he constructed the image purely on the basis of colour, which has now become autonomous, and no longer fulfils any external representational function, but develops on the surface according to its own laws of movement. The materiality of the colour, its formative energies, intervals, and contrasts, here become the subject of painting itself.

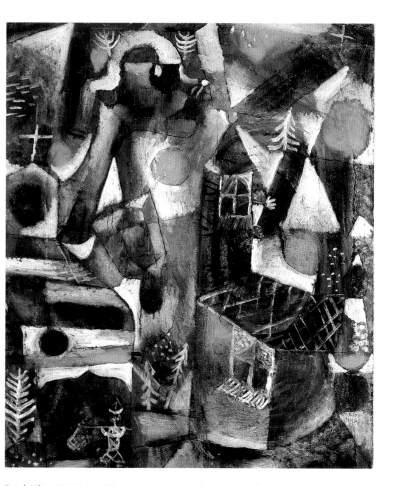

Paul Klee (1879–1940)
Swamp Legend, 1919
Oil on carton, 47 x 40.8 cm
The *Swamp Legend* is one of the first oil paintings that Klee produced after a long series of graphic sheets, drawings, and finally colourful watercolours. Architectural elements and damp vegetative life-forms, organized and amorphous shapes are all intertwind here in inexplicable ways. The interplay between inorganic and organic elements was to become a central concept in Klee's creative work as a whole. The imaginary quality of the forms depicted in *Swamp Legend* also reflects his taste for the 'primitive' art of both children and the mentally ill.

Paul Klee (1879–1940)
Destroyed Town, 1920
Oil on paper, mounted on grey-blue carton, on cardboard, small silver margin oxidized around the picture, 22.3 x 19.5 cm
The painting is one of the few works by Klee that refer to the experience of the war that had just ended. Various statements by the artist describe the sense of inward distance with which he observed the war. It is characteristic of the special type of 'passionless ardour' in Klee's pictures that one views the town in this painting with horror.

Paul Klee (1879–1940)
Rose Garden, 1920
Oil on carton, 49 x 42.5 cm
The subject of the garden, so important to Klee, already contains the dual principle of artistic, structured order and natural, organic growth. *Rose Garden* is the most important of a series of works produced around 1920 in which he fuses organic and architectural structures into a rhythmic pictorial whole. The construction of a landscape using graphically exact, cross-layered structures is often related by Klee to analogous concepts in music—a link that is fun-

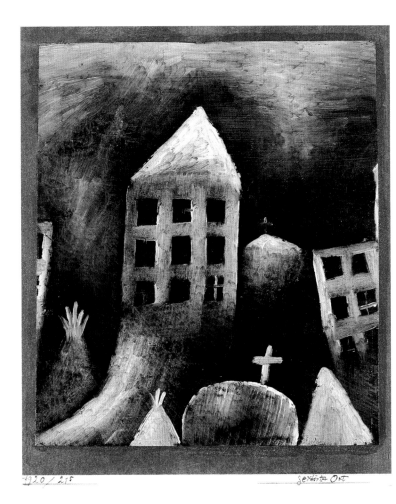

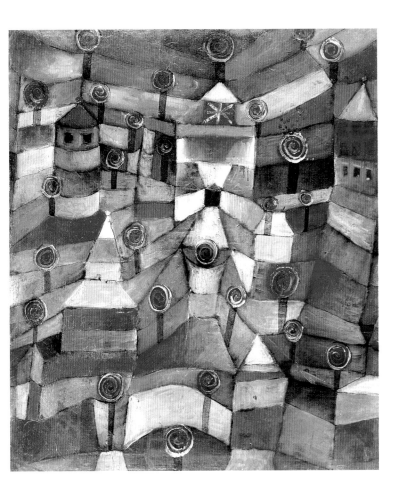

damental to Klee's view of the constructional laws of the pure, autonomous painting that Kandinsky, too, was seeking.

the 'intoxication of the perpetual processes of change in nature', as well as the isolation of the shapes symbolizing human beings, animals, and plants.

Paul Klee (1879–1940)
Intoxication, 1939
Oil on watercolour on jute,
65 x 80 cm
In increasingly 'primitive' drawings, returning to the sources, Paul Klee's painting rose to a final climax towards the end of his life. The broken figures may suggest, in a hieroglyphic form,

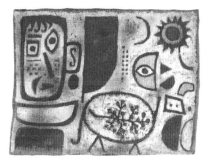

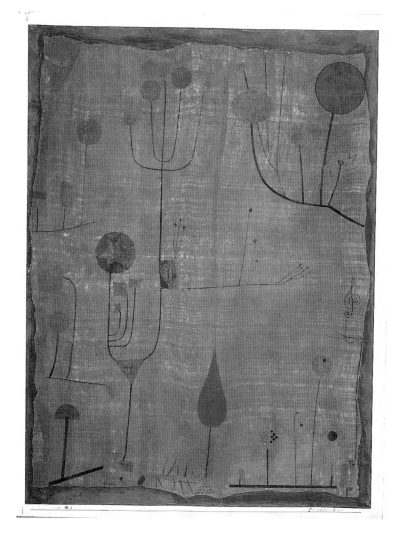

Paul Klee (1879–1940)
**Fruit on Red—the Violinist's
Sudarium**, 1930
Watercolour on silk with silk
appliqué, 61.2 x 46.2 cm
The subject of this painting is
vegetative growth, and it shows
the natural development from the
tiniest, berry-like buds to ramified
shoots, from the blossom to the
fruit. The motif of the stage cur-
tain, suggested in the upper left
corner, was one that appeared in
many of the artist's works after
1918. The original function of the
red silk cloth, which Klee had earl-
ier used to protect his violin when
playing it and which here served
him as the basis for a painting, is
subtly indicated by the treble clef
symbol on the right edge of the
picture. In the title, 'the violinist's
sudarium' refers ironically to the
'sudarium' of St Veronica, which
in Christian art is thought to con-
tain the true image of Christ.

Neue Sachlichkeit

In contrast to names like 'Blue Rider' and 'Die Brücke', the term 'Neue Sachlichkeit' (New Objectivity) was not an expression of an artistic concept that was chosen by the artists themselves, but describes a shared period quality that was recognized by art scholars and critics in the painting of their time.

The term was first used by Gustav Friedrich Hartlaub, director of the Kunsthalle in Mannheim, who opened an exhibition in Mannheim in 1925 under the title 'Neue Sachlichkeit'. Under this programmatic term, he gathered together various trends in post-war German art. What the Neue Sachlichkeit artists had in common was a renewed attention to the sober, realistic reproduction of reality, which for most of them implied a critical distancing from their Expressionist predecessors. Even Hartlaub drew a distinction between various tendencies within the Neue Sachlichkeit: a 'veristic' one that was critical of contemporary issues and of society, centring on the Berlin painters George Grosz and Otto Dix; and a 'classicist', idealizing tendency, whose principal representatives are held to be Alexander Kanoldt and Georg Schrimpf. At around the same time as Hartlaub, Franz Roh introduced the term 'magic realism' for German painting of the 1920s. The term is now only used to refer to a group within the Neue Sachlichkeit, the most prominent member of which was Franz Radziwill.

Paintings and sculptures by Karl Röhrig, Josef Scharl, Christoph Voll, and Heinrich Ehmsen in Room 29

The different varieties of the Neue Sachlichkeit can more or less be localized as follows: the artists oriented more strongly towards social criticism, such as Grosz, Schlichter, and Schad in Berlin, Dix and Felixmüller in Dresden, and Hubbuch, Schnarrenberger, and Scholz in Karlsruhe, stand in contrast to the Munich painters influenced by the Italian group of artists associated with the journal *Valori plastici* (Carlo Carrá, Giorgio de Chirico), such as Schrimpf, Kanoldt, and Mense. The latter avoid aspects critical of society, and belong to the out-and-out idyllicists. Almost all of the artists left Munich as early as the 1920s, because the crushing of the Bavarian soviet republic in 1919 was followed by an increasingly chauvinistic atmosphere that prepared the way for the rise of Nazism, making the conditions for the creation of modern art much more difficult, if not impossible.

Left: View from Room 29, with paintings by Georg Schrimpf and sculptures by Fritz Koelle and Rudolf Belling, into the Lenbach room, Room 30

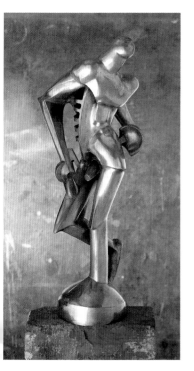

Rudolf Belling (1886–1972)
Organic Forms (Striding Man), 1921
Bronze, silver-plated, height 53.3 cm
The sculptors of the Neue Sachlichkeit generally took up traditional topics—the whole human figure, or the portrait head as the most common subject. Rudolf Belling, who until his emigration in 1937 belonged to the socialist-oriented November group, counts as one of the best-known sculptors of the Weimar Republic. The sculpture *Organic Forms (Striding Man)* clearly reflects his productive study of the sculptural experiments of the Cubists and Italian Futurists. A machine-like aesthetics and an optimistic faith in the 'new Man' are combined in this important early work by Belling.

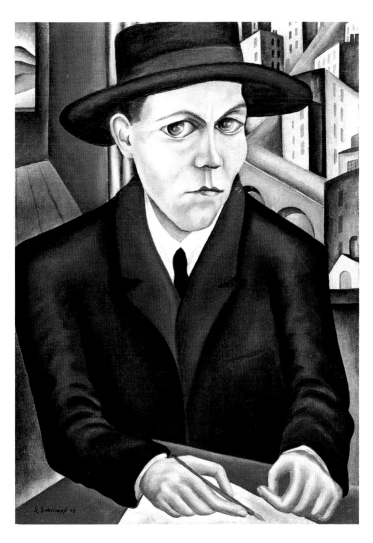

Georg Schrimpf (1889–1938)
Portrait of Oskar Maria Graf,
1918
Oil on canvas, 45 x 67 cm
The portrait of the Munich writer was produced during the soviet republic in Munich, in which Schrimpf and Graf, who had been friends since 1911, were key figures. The portrait is the earliest one of Oskar Maria Graf, to whom the revolutionary year of 1918 brought his first successes as a writer. It shows him in a field of tension between his country home and the city. The picture was one of the works which Schrimpf produced after the death of his first wife, the painter Maria Uhden, on 14 August 1918, and which show him as a mature painter. The suspension of the figure in space and the colouring, based on intensive local toning, show a persisting connection with Expressionist painting. At the same time, however, its view of the urban landscape from above heralds an attitude reminiscent of Giorgio de Chirico's *pittura metafisica*.

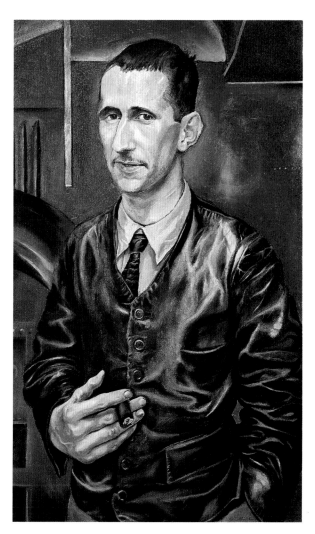

Rudolf Schlichter (1890–1955)
Portrait of Bert Brecht, ca. 1926
Oil on canvas, 75.5 x 46 cm
The politically committed portrait painter Rudolf Schlichter was forbidden to exhibit during the Nazi period. He was a member of the German Communist Party, belonged to the Dada Group in Berlin, and had close connections with George Grosz and Otto Dix. He lived in Munich from 1939 on. His portraits witness to a capacity for a kind of psychological empathy in which he orients his stylistic means around the model. With angular ridges of light and the marked shape of a car in the background, he gives the portrait of his friend Bert Brecht a special accentuation —indicating Brecht's passion for his car, received in gratitude for a poem celebrating Steyr cars. The leather jacket signalizes solidarity with the proletariat. The car and the fat cigar are in sharp contrast to this, as well as to the content of Brecht's plays which, at the time, were receiving their spectacular opening performances.

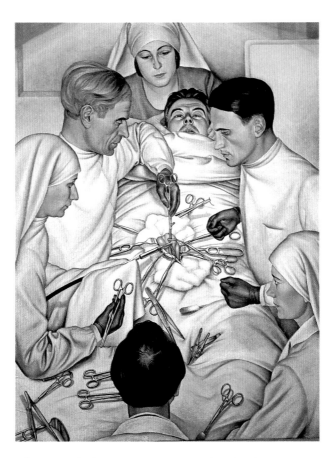

Christian Schad (1894–1982)
Operation, 1929
Oil on canvas, 125 x 95 cm

While a certain stillness and presence of the objects is dominant in the work of the 'classical' Neue Sachlichkeit artists such as Kanoldt, Mense, and Schrimpf, the objective world acquires a threatening, and even uncanny, undertone in that of other painters, who are held to represent the 'magic realism' movement. Paintings such as Schad's *Operation*—one of the major works of the Neue Sachlichkeit—move in this direction. The subject here is injury to the body or the exposure of its functioning, with strange confrontations in the picture between living and abstract-functional elements. The fact that he used a portrait of one of his friends as the patient in the operation also indicates a breach with reality, resulting from Schad's early Expressionist and Dadaist phase. Formally, the painting recalls the scene of the Mourning of Christ in Christian art. The patient's body is in the same position as that in Mantegna's famous Christ, viewed from the soles of his feet. In the centre of the picture, the patient's appendix is visible, undergoing cauterization. All of the figures' gazes, as well as all instruments, are pointing towards it. The open wound seems to be not unrelated to the depiction of the Sacred Heart. In its solemn seriousness, the painting is a profane reproduction of a sacred subject.

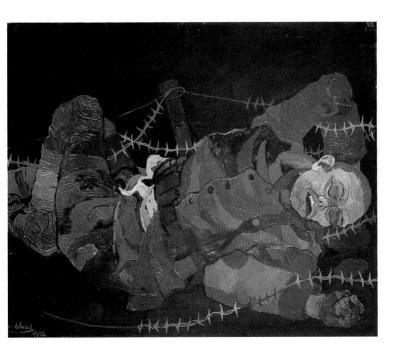

Josef Scharl (1896–1954)
Fallen Soldier, 1932
Oil on canvas, 81 x 100 cm
Josef Scharl, who painted pictures
that were critical of society and
anti-militaristic, emigrated to New
York in 1938. He had contacts
with Albert Einstein, and painted a
portrait of him for the first time in
1927. The painting *Fallen Soldier*
documents the artist's pacifism: it
is not the death of a hero that is
depicted here, but that of a human
being who has succumbed to his
injuries like a helpless animal,
caught in the barbed wire barrier.
The tense limbs and the face
distorted in pain form an image
of misery that has nothing what-
soever to do with the emotional
representations of the so-called
hero's death on a 'field of honour'
that were customary in contem-
porary memorials to the war dead.
Particularly in Munich, there was
a much-noted sculpture, Bernhard
Bleeker's The *Dead Soldier*, which
stood at the most prominent point
in front of the Army Museum,
and formed the centrepiece of the
memorial to the dead of the First
World War that was set up in
1924. Scharl and his portrait,
which can be seen as a commen-
tary on Bleeker's monument, be-
longed to a completely contrary
tradition, which is also seen in the
work of Otto Dix.

Contemporary Art

The vast increase in the size of the museum's collections resulting from the addition of the works of the Blue Rider group meant that a purely local Munich focus for the collection, as well for other activities at the Lenbachhaus, could no longer be sensibly justified. Particularly since the 1970s, exhibition activities at the Lenbachhaus have expanded considerably, displaying the works of artists and subjects of international significance. In principle, the idea since then has been to relate the collection of more recent art to the museum's exhibition activities, since these provide the best insight into the work of the relevant artists. The Lenbachhaus does not collect works in any encyclopaedic fashion, but

Rupprecht Geiger (b. 1908), New Red for Gorbachev, *1989*

concentrates in its new acquisitions on the work of individual artists who can then be represented by complex groups of works, or by spatial installations. This approach is based on a recognition that in contemporary art, in particular, it is almost impossible to appreciate the complexity of an artist's intentions from a single work alone. The purchase of Joseph Beuys's *show your wounds*, produced in 1974–75 and exhibited first at the Kunstforum, an exhibition room belonging to the Städtische Galerie, launched an extremely ferocious and controversial political discussion, after which it was possible to secure the work for the Lenbachhaus in 1980. This was followed by installed rooms and groups of works by Anselm Kiefer, Gerhard Richter, Sigmar Polke, Franz Gertsch, James Turrell, Andy Warhol, Michael Heizer, Sean Scully, Catherine Lee, Dennis Adams, Richard Serra, Dan Flavin, Jenny

Holzer, Ellsworth Kelly, Arakawa, François Morellet, Christian Bol-
tanski, Asger Jorn, Arnulf Rainer, Rupprecht Geiger, Günther Fruh-
trunk, Roman Opalka, Maurizio Nannucci, Isa Genzken, Ulrich Horn-
dash, Stephan Huber, Albert Hien, Alf Lechner, Günter Förg, Ernst
Hermanns, Gerhard Merz, and many others. These purchases have
been listed in the museum's annual reports since 1981. A catalogue of
this section of the museum's collections is being prepared.

Several of the rooms were installed at the Lenbachhaus by the artists
themselves. These rooms are the cornerstones of our collection, and
create a new form of identification with the building. At the same time,
the museum has thereby acquired a virtually unmistakable quality. The
attempt by Gerhard Merz to give his cycle of works *Mondo Cane* its
own presence in the historical Lenbach rooms serves—in the same way

Room 46, with works by Gerhard Richter

as the integrated works of Ulrich Horndash, Lawrence Weiner, and Maurizio Nannucci—to link the existing architectural ambience to current pictorial concepts. The modernness of Gerhard Merz's procedure in 1983 of hanging his paintings on the coloured, fabric-covered walls, can be seen alongside the fundamental ideas of a figure such as Blinky Palermo—exemplified in the room with Gerhard Richter's *Two Sculptures for a Space by Blinky Palermo* (1971)—a fundamental and pioneering approach for the museum as a whole. The leitmotiv of colour that accompanies the visitor through the nineteenth-century rooms, via the historical Lenbach rooms and the Blue Rider and thence to the modern period, has grown out of experience and from the encounter with artists during their exhibitions. It is intended to make the experience at the Lenbachhaus an event that is out of the ordinary.

Sigmar Polke (b. 1941)
Hollywood, 1971
Mixed media on mattress material, in two parts, 180 x 180 cm and 110 x 130 cm
Polke has worked in a series of pieces with colourfully printed textiles. He contrasts his painting to the colourfulness and patterning of the textiles that serve as the basis for the image. Here, we are apparently faced with shorthand and ciphers for film stars from a movie of the 1920s or 1930s. The source of the image was a film advertisement. In the smaller image, Polke makes the parrot from the mattress material into the actual pictorial subject itself. Pictorial sources in the form of photographs or older works of art are often seen in Polke's work. An unexpected pictorial experience results from their paraphrasing, from the unusual context and the way in which he presents the motif afresh each time. However, since Polke pursues several very different pictorial strategies, the intentions behind his work only emerge from the context of his other pieces, as in the striped image of 1962–68 and the lacquer picture *Tibet* of 1983.

Arnulf Rainer (b. 1929)
Crossed Heart, 1959/1973
Oil on wood, 208 x 81 cm
This work by Arnulf Rainer belongs to a whole series of paintings concentrating on the subject of the cross. The earlier pieces, dating from 1959 and in the years to follow—as in another cross image by Rainer also in our collection— are essentially restricted to black overpaintings, in which the process of covering up, equivalent to a form of ascetic privation, is intended to provide access to a form of concentration and inward contemplation. In his concentration on an obliterative colour, Rainer's utmost intention is to achieve a process of absolutization and inwardness. In *Crossed Heart*, however, another dimension in his work is also expressed—namely that of the immediacy of the spontaneous gesture. Paint applied directly to the surface using the fingers is a means of liberating humanity. The spontaneous, living process

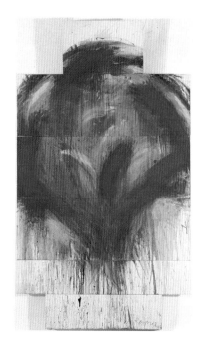

of action that can be visually grasped by the viewer is an expression of consternation and of a will to act.

Andy Warhol (1930–1987)
Lenin, 1986
Acrylic with screenprint on canvas, 213 x 178 cm
It was not the individual personality that was Andy Warhol's central interest in his portraits, but the image conveyed by the media, the cliché. One of his last great series of pictures was based on a photograph of the leader of the Russian Revolution, Vladimir Ilyich Lenin, which Enzo Cucchi drew to the attention of the Munich gallery owner Bernd Klüser in Rome at the end of 1985. Klüser in turn showed it to Andy Warhol in New York shortly afterwards. The source photo is a retouched, polit-

ically 'purged' detail from a group portrait of the 'Petersburg League of Struggle for the Liberation of the Working Class', taken in 1897. Typologically related to the depiction of the apostles and church fathers, leaning on books, gazing out of the picture at the observer, a new 'icon' has been created, which is deprived of its uniqueness by Warhol's duplication process. Warhol extended the formal severity and clear structure of the frontally viewed portrait by simplifying the picture's background and utilizing drawing techniques to highlight less representational elements with strong contour lines.

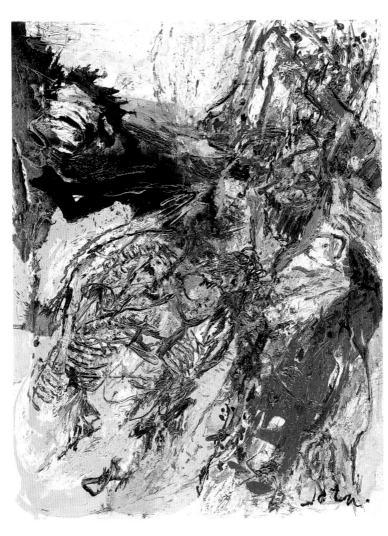

Asger Jorn (1914–1973)
They Never Come Back, 1958
Oil on canvas, 146 x 114 cm
In the post-war period, Asger Jorn played an important part in artistic development through his dominant influence on the 'CoBrA' group of artists, an association of Danish, Dutch, and Belgian artists (Copenhagen, *B*russels, *A*msterdam = CoBrA). The group's paintings are full of amorphous mixtures of strange birds, masks, and enigmatic figures. Jorn, however, avoided all forms of simplicity,

and concentrated on the painterly elaboration of his depiction. Even while painting, gnomes, trolls, and nightmarish shapes kept appearing, which could only be captured by pictorial deformation, without losing their frightening qualities. The same applies to another painting in the collection, entitled *The Bad Year* (1963). A wide variety of rhythms and levels of movement in the paint and thus in the symbolic suggestions interpenetrate one another in this painting, as if in a psychological labyrinth.

Sean Scully (b. 1945)
No Neo, 1984
Oil on canvas, 243.8 x 304.8 cm
In the work of Sean Scully, who was born in Dublin, grew up in London, and has lived in New York since 1975, a clear link can be seen, more so than in most other painters of his generation, between the European pictorial tradition and the innovative approaches seen in American painting, for example in the work of the New York School after 1945. Scully's paintings basically deal with the pictorial problem of how to achieve a clearly delimited formal structure while simultaneously releasing the full potential of painterly qualities. On this basis, he studies the various densities, transparencies, and material qualities of colours, as well as all the various ways of relating tones and making areas of colour more or less prominent. Since the beginning of the 1980s, Scully has been basing his pictures on several elements, each of which possesses a striped structure of two alternating colours. The renunciation of cold perfection in favour of a sensuous treatment of colour is a decisive component in the aesthetic quality of his paintings.

Joseph Beuys (1921–1986)
show your wounds, 1974–75
Spatial installation constructed by
the artist in the Lenbachhaus,
1980; 5 double objects: biers for
corpses; tools, pitchforks, news-
papers, school blackboards
The purchase of this environment
by Joseph Beuys gave rise to strong
feelings among the wider public in
1979. The artist had grouped used
relics from everyday life in pairs in
a special arrangement in a room,
including old biers for corpses
from a pathology department. This
direct reference to death—which
through the other relics is placed
in a context continuous with that
of the individual observer's social
location—transgresses a taboo and
evokes defensive reactions and a
sense of aggression towards what
the artist is presenting. The artist
himself responded to the question
of what his environment meant by
saying that he had principally been
concerned with making visible the
death zone towards which modern
society is moving at such high
speed.

Anselm Kiefer (b. 1945)
Ways of Worldly Wisdom: The Battle of the Teutoburg Forest, 1978–80
Woodcut, acrylic, shellac on paper, 344 x 413 cm
The artist presents a series of 29 large woodcut portraits grouped around a tree, in front of which there is a blazing fire. The Battle of the Teutoburg Forest in 9 AD, in which Arminius (Hermann, the chief of the German Cherusci tribe) defeated three Roman legions under Publius Quintilius Varus in the Teutoburg Forest, became in the nineteenth century a symbol of the struggle for liberation, partly due to the parallel that was drawn with the struggle against Napoleon. Many poets and painters took up the theme. In this picture, Kiefer uses the title to link the historical event to artists and other representatives of German history in the nineteenth and early twentieth centuries, whose thoughts and actions are respons-

ible for the country's situation today. The forest, as a German symbol, with the warming and destructive fire in front of it, gathers round it figures who are all cut from the same wood. Through the title *Ways of Worldly Wisdom*, an accidentally discovered title from a book of historical reflections by a Jesuit priest, the battle is linked to an intellectual and historical system that reaches beyond its own specific context in history. Kiefer's *Women of the Revolution* is a counterpart to this picture.

Anselm Kiefer (b. 1945)
Women of the Revolution, 1986–87
5 lead sheets, each 330 x 130 cm, on chipboard, dispersion,
17 glazed lead frames with dried flowers, lead object, 330 x 650 cm
This monumental work by Anselm Kiefer consists of five plates covered in lead, combined to form a large surface. The lively grey, with

its iridescent changes into various nuances, gives the heavy material a light, transparent effect in places. Lead frames are attached to the tableau in a loose arrangement; under each of the glass sheets, one can see a dried flower in front of the lead background. They form a kind of portrait gallery: the names of women who were involved in the French Revolution can be read on the frames. The iconographic key to Kiefer's selection lies in Jules Michelet's 1854 book *Les Femmes de la révolution*, which presents the women's biographies.

layer that separates the photographic shot, its projection onto the wooden block (which is primarily used for checking purposes) and the final image. The shadow elements in the image are printed, while in the carved-out light areas the colour of the paper continues to be seen. Gertsch does not produce editions of his woodcuts, as is usual with this technique, but concentrates instead on producing strictly determined series in various colours.

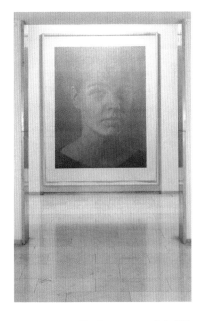

Franz Gertsch (b. 1930)
Natasha IV, 6/18, 1987–88
Woodcut on Heizoburo Japanese paper, 232.5 x 182 cm
Two different levels of observation interpenetrate in Franz Gertsch's large-format woodcuts: that of the monochrome colour surface and that of the photographically exact image. Two ways of looking, therefore, which are in principle mutually exclusive, are set on an equal basis here, and they encourage a dialogue between different conceptions of design and image. By developing his pictures via woodcuts, Franz Gertsch creates a

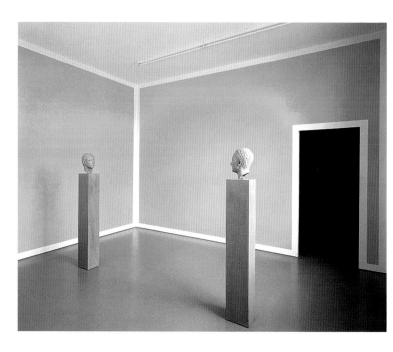

Gerhard Richter (b. 1932)
Two Sculptures for a Space by Blinky Palermo, 1971,
reinstalled 1984
Bronze painted with grey oil paint, pedestals in black granite, painted with grey oil paint, 142 cm high, heads 31 cm high, wall painting in 'Munich yellow', ceiling and corners of the walls white
In 1971, Palermo (1943–77) executed a wall painting in Munich's Galerie Heiner Friedrich. The walls were given a monochrome coat of paint in 'Munich yellow', and the boundaries of the room were emphasized by a white stripe, about the width of a hand, all round the corners. The picture (as a monochrome surface) was thus replaced by a coloured surface design on the wall. In the same year, Palermo installed this spatial concept for a second time in Heiner Friedrich's Cologne gallery. Two sculptures by his friend Gerhard Richter were added—bronze castings of plaster casts, defamiliarized by painting, of the heads of the two artists who had jointly produced the installation. The heads, which like their marble pedestals are covered in grey oil paint, were set frontally opposite one another on the room's longitudinal axis. The space thus automatically becomes a documentation of the friendship between two artists, and at the same time, with an ironical twist, a memorial, with the heads' closed eyes accentuating the ambiguity of the environment: they can be interpreted as an 'inward gaze', and thus as a moment of inspiration, or as a reference to death.

Ellsworth Kelly (b. 1923)
The Documenta-Room
Blue Panel with Curve, 1991
Oil on canvas, 269 x 221 cm
White Panel with Curve, 1992
Oil on canvas, 222 x 217 cm
Green Panel with Curve, 1992
Oil on canvas, 306 x 191 cm
Red Panel with Curve, 1991
Oil on canvas, 277 x 227 cm
In contrast to his American contemporaries who demanded a radical departure from European art, Ellsworth Kelly developed his pictorial language from an intensive study of modernist traditions, encountered during a stay in France that was particularly decisive for him, from 1948 to 1954. Kelly draws his colour forms from geometrical structures perceived in reality. In this way, he hopes to stimulate an increased awareness for the aesthetic dimensions of given forms, which, when detached from all external signifying references, appear to become objectified. Each of the four individual pictures in this group of works, originally created for 'documenta IX', has its own complex shape, related to a segment of a circle, and each at the same time stands in relation to the surface of the wall as a ground. The green picture's apparently precarious way of standing on a point, for example, acquires a latent momentum of movement which it is impossible to localize.

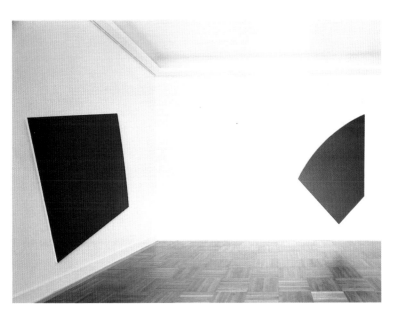

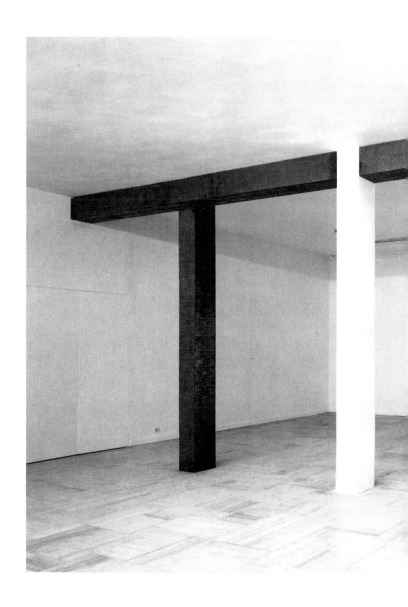

Richard Serra (b. 1939)
Gate, 1987
Sculpture, wrought iron, 2 supports, each 364 x 31.5 x 32 cm, 2 bars, each 446/522 x 32 x 32 cm
Richard Serra created six new works for the exhibition '7 Spaces—7 Sculptures' at the Städtische Galerie im Lenbachhaus, which were all directly related to the architectural conditions in the exhibition rooms. The massive steel sculpture *Gate*, composed of two double elements, which divides the room as a 'gate' with four openings on one level, relates specifically to the room the Lenbachhaus for which it was created. With its energy and power, the sculpture cancels out the architecture and takes over the ordering of the room.

James Turrell (b. 1943)
Side Look, 1992
Spatial installation: fluorescent light, tungsten fan light, daylight
James Turrell's installations open up spaces that are shaped by light alone. The material qualities of the light, isolated from all surrounding references, can be grasped as objects of perception. Turrell's work therefore aim to achieve a tactile form of vision which makes the physical presence of light perceptible. The installation *Side Look* confronts the observer with a visual phenomenon that presents an immense challenge to his or her perceptual abilities. A wall with a horizontally arranged oblong section divides two areas—the observer's space and the light space—which, purely as a result of their different lighting, create the illusion of standing in front of a 'picture'. As the eyes become accustomed to the extremely reduced light, the observer notices a gradual intensification and change in the colours in the wall section, produced by a mixture of fluorescent light and daylight, and behind it an 'anti-space' slowly begins to become perceptible. In the semi-darkness, which only presents the coloured light surface in full clarity, the observer's perceptions are intensely sensitized.

Christian Boltanski (b. 1944)
Les Images honteuses EL CASO, 1992
Installation with 9 display cases (metal, glass) with photographs concealed in scraps of white fabric, framed photograph (110 x 165 cm) with black curtain, lamp
In his work, Christian Boltanski presents a world of shock, fear, and horror. The works always present wounds of memory. His fundamental subject is death in its inescapability, but also as an individual and historical event. *EL CASO* is a Spanish weekly magazine that exclusively publishes photographs of violent crime. Starting from this horrific material, Boltanski has constructed sarcophagus-like display cases in which photographs from the magazine are concealed, wrapped in scraps of white linen. The connec-

tion between the desk-like display cases and sepulchral forms associates the ideas of showpieces and death. White linen crushed together suggests clothes that have been stolen from people, and of course the Jews who were robbed of their clothing before being dispatched to the gas chambers. Generally, however, pieces of clothing, torn, detached from the human body, or only covering it scantily, are often seen in the context of bodies that have been violated by accidents and crimes. A large-format photograph behind glass, covered by a black curtain, and lit only by a gloomy office lamp, might be able to satisfy the observer's voyeuristic tastes. But the greedy gaze is frustrated here by an image that has been rendered illegible by over-enlargement. Although, or perhaps precisely because, all of the pictorial elements are only present in a diffused fashion, the work communicates an oppressive sense of violence.

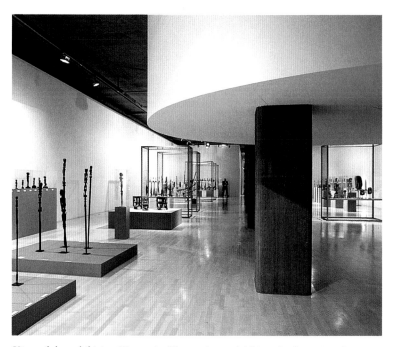

View of the exhibition 'Tanzania: Masterpieces of African Sculpture' in the Kunstbau, 1994

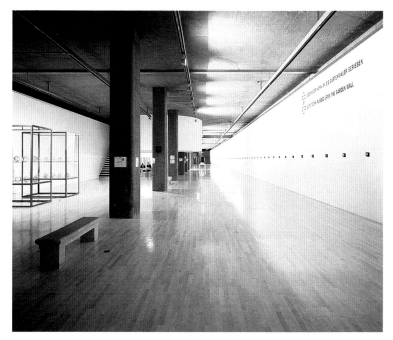

View of the exhibition 'Rosebud: Jenny Holzer, Matt Mullican, Lawrence Weiner' in the Kunstbau, 1994

Exhibitions at the Lenbachhaus

1985
German Video Art 1982–84.
Franz Roh. Jannis Kounellis.
Louis Soutter. Mimmo Paladino.
Gabriele Münter, Drawings and
Watercolours. Drawings of Paul
Klee, 1921–1933.

1986
Adolf Wölfli. Dieter Froese.
Tomiyo Sasaki. Markus Lüpertz.
Herbert Achternbusch. Artists
Working with Video (Ulrike Ro-
senbach, Klaus vom Bruch, Her-
bert Wentscher, Gústav Hámos).
Hugo Ball. Günter Brus. Carl
Schuch. Homage to Beuys.
German Video Art, 1984–86.
Hans Namuth.
Franz von Lenbach. Erwin Steiner.
Cultural Assets – Bombproof?
Dresden and Hiroshima Appeal
for Reason and Peace (documen-
tary exhibition).

1987
Asger Jorn. Manfred Boecker,
Wolfgang Niedecken. Gilbert and
George. August Macke. Enzo
Cucchi. Edgar Ende. Richard
Serra.

1988
Vladimir Spacek. Vassily Kandin-
sky, Watercolours and Drawings.
Between the Elbe and the Volga:
10 Photographers from Eastern
Europe and the GDR.
Zero: Vision and Movement—
Works from the Collection of Lenz
Schönberg. Hermann Nitsch.
German Video Art, 1986–88.

1989
CoBrA, a European Movement.
William Henry Fox Talbot. Sean
Scully. Gerhard Richter. Karl
Schmidt-Rottluff.

1990
Xanti Schawinsky. Heinrich Cam-
pendonk. Vladimir Vinsky. Louise
Bourgeois. From Eisenstein to Tar-
kowsky: Paintings by Soviet Film
Directors. Antonio Saura. Picture
by Picture: Acquisitions, 1974–90.
Alf Lechner. Walker Evans.
Alfred Kubin. German Video Art,
1988–90. Les Levine.

1991
Getlinger photographs Beuys.
Rudolf Bonvie. Paradoxes of
Everyday Life (Guillaume Bijl, Luc
Deleu, Denmark, Panamarenko,
Ludwig Vandevelde, Liliane Ver-
tessen). Ferdinand von Rayski.
Nikolaus Lang. Albert Hien.
Expressionist Greetings: Postcards
by Artists of 'Die Brücke' and the
Blue Rider. Angela Neuke. Franz
Gertsch. Maurizio Nannucci.
Argus Eye (Dennis Adams, Silvie
and Chérif Defraoui, Hans
Haacke, Tamara Horakowa and
Ewald Maurer, Marie-Jo Lafontai-
ne, Esther Parada). Hans Danuser.
Wilhelm Morgner.

1992
Martin Disler. Chung Eun-Mo.
Rainer Wittenborn. Claes Olden-
burg. Catherine Lee. Ulrich Horn-
dash. Gabriele Münter Retro-
spective. Roman Opalka.

1993
Ken Lum. Günter Tuzina. Rudolf
Steiner. Isa Genzken. Antonio
Dias. Ideal and Nature: Water-
colours and Drawings at the Len-
bachhaus 1780–1850. Günter
Fruhtrunk. Auguste Chabaud.
South German Freedom: Art of
the Revolution in Munich, 1919.
Ian Hamilton Finlay. Adriaan
Korteweg.

1994
Sophie Taeuber-Arp. Expressionist Paintings from the Ahlers Collection. Views: Photographic Images by Munich Artists. Jon Groom. Bordeaux: Between Sky and Water—Works from Bordeaux Museums.

1995
Helmut Kolle. François Morellet. Ulrich Rückriem. Stefan Hunstein. Franz Marc. Maria Marc. Ernst Geitlinger.

Exhibitions in the Lenbachhaus Kunstbau
(opened April 1994)

1994
Dan Flavin. Chuck Close. Tanzania: Masterpieces of African Sculpture. Rosebud: Jenny Holzer, Matt Mullican, Lawrence Weiner.

1995
The Battle of the Sexes—the New Myth in Art, 1850–1930. With the Eyes of a Child: Children's Drawings and Modern Art. Hamish Fulton. Colourful Life: Vassily Kandinsky at the Lenbachhaus.

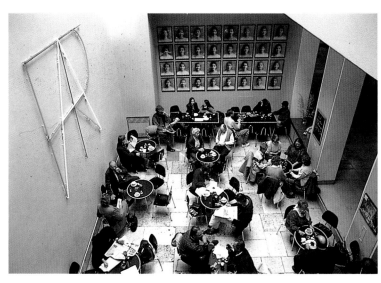

The Lenbachhaus café, with the neon work ART by Maurizio Nannucci, 1991

Selected Bibliography

Sonja Mehl. *Franz von Lenbach in der Städtischen Galerie im Lenbachhaus München*. With a contribution by Christine Hoh-Slodczyk. Munich, 1980.

Rosel Gollek and Winfried Ranke. *Franz von Lenbach 1836–1904*. Exhibition catalogue, Munich: Städtische Galerie im Lenbachhaus, 1987.

Rosel Gollek. *Der Blaue Reiter im Lenbachhaus München*. Catalogue of the Collection of the Städtische Galerie. 3rd edition, Munich, 1985.

Armin Zweite, ed. *Der Blaue Reiter im Lenbachhaus München*. Munich, 1991.

Rosel Gollek, ed. *Franz Marc 1880–1916*. Exhibition catalogue, Munich: Städtische Galerie im Lenbachhaus, 1980.

Armin Zweite, ed. *Kandinsky und München: Begegnungen und Wandlungen 1896–1914*. Exhibition catalogue, Munich: Städtische Galerie im Lenbachhaus, 1982.

Annegret Hoberg and Helmut Friedel, eds. *Gabriele Münter 1877–1962: Retrospektive*. Exhibition catalogue, Munich: Städtische Galerie im Lenbachhaus, 1992.

Helmut Friedel, ed. *Dan Flavin. Kunstbau Lenbachhaus München. Architektur Uwe Kiessler*. Exhibition catalogue, Munich: Kunstbau der Städtischen Galerie im Lenbachhaus, 1994.